The Scottish Mountains

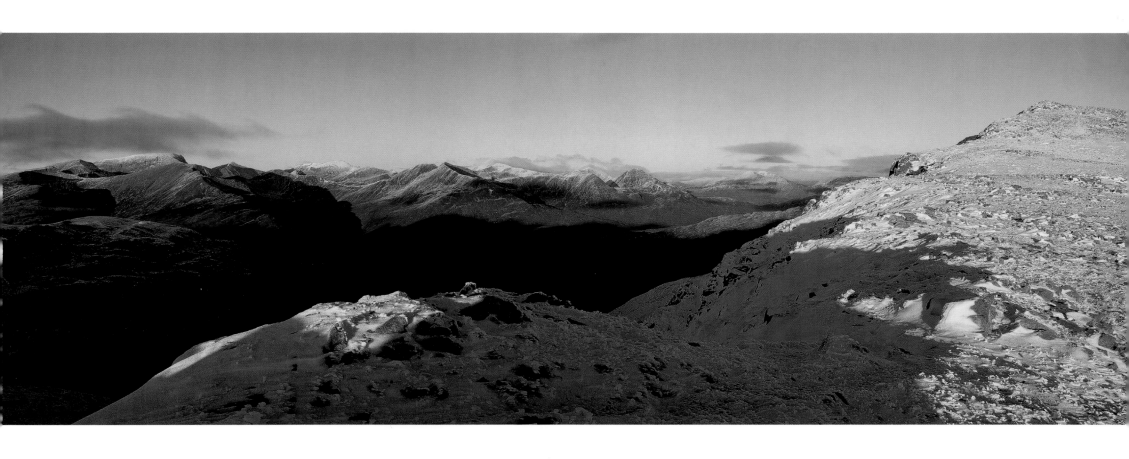

First published in Great Britain in 2007 by
Colin Baxter Photography Ltd.,
Grantown-on-Spey
PH26 3NA, Scotland

www.colinbaxter.co.uk

Photographs by Alan Gordon © Alan Gordon 2007
Introduction and Chapter Texts by Hamish Brown © Colin Baxter Photography Ltd. 2007
Picture Captions by Alan Gordon

ISBN 978-1-84107-367-5

Front Cover: Late autumn in the Central Highlands – Sgorr na Ciche (the Pap of Glencoe), Beinn a' Bheithir and the distant mountains of Mull, from Na Gruagaichean.
Back Cover: The southern peaks of the Cuillin, from the ridge north of Sgurr na Bhairnich.
Page 1: Winter sunset on Ben Nevis and the Mamores, from the ridge east of Aonach Eagach. *Page 3*: Ben Cruachan and Loch Etive from Beinn Sgulaird

Printed in China

The Scottish Mountains

photographs by ALAN GORDON text by HAMISH BROWN

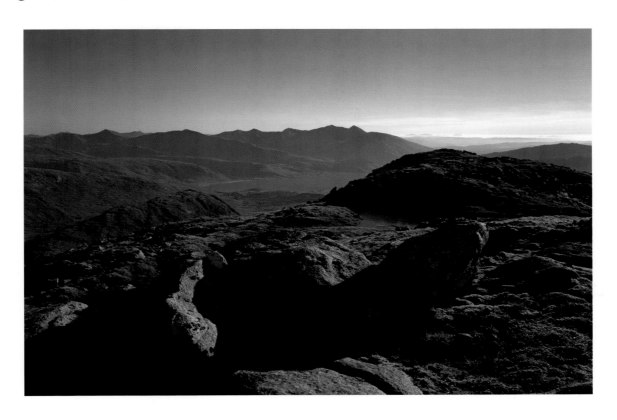

Colin Baxter Photography Ltd, Grantown-on-Spey, Scotland

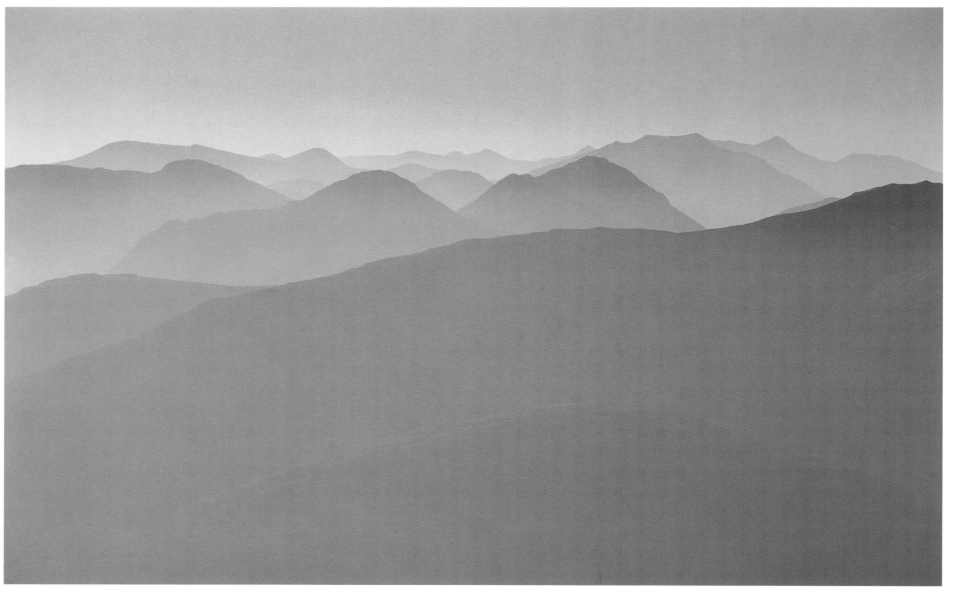

The ridges of the Blackmount and the Etive hills rise above a late autumn mist, seen from Sgurr Eilde Mor in the Mamores.

Contents

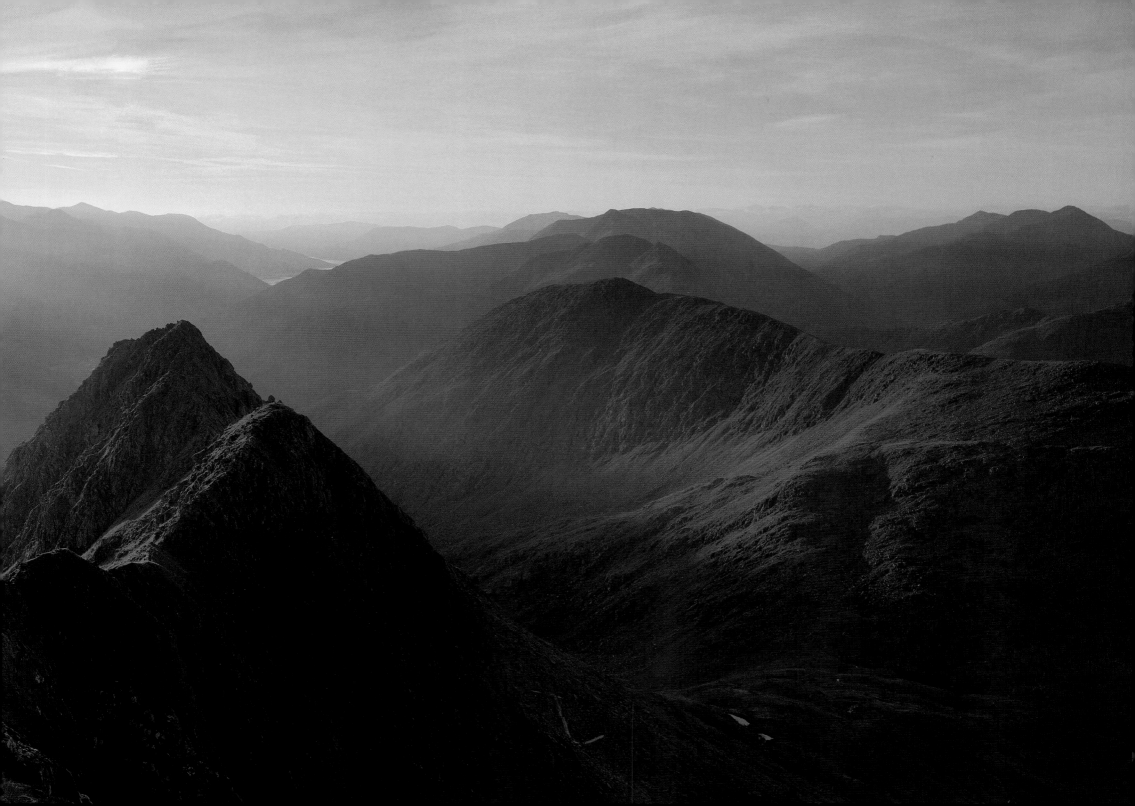

The Scottish Mountains

Anybody can take photographs; millions do and prove it by enthusiastically boring family and friends with their efforts. The digital revolution is both bane and blessing. In any school playground you will see children using their mobile phones to take shots of their posturing pals. World-over, a TV camera has people fighting to be captured by the lens. How very different is the world portrayed in this book.

There are not many people 'strutting their stuff' on high hills but then Alan is apt to be busy alone; with camera and tripod weighing in at five kilos, hurrying is hardly possible, never mind the time needed to actually take the shots or the greater time, effort, dedication and imagination to be in the right place at the right time. These are not lay-by pictures. They are a unique collection of mountain images, from among the hills themselves, from high on the hills, a world which is wonderfully captured for us.

Early efforts at colour photography were hardly remarkable, were often stereotyped and garish, working treadmill traditions rather than seeking new challenges. So I well remember the shock following the Scottish Mountaineering Club's *The Munros* and, in some ways more so, *The Corbetts* book. 'You'll never get any decent pictures' I was often told as an editor but how wrong that proved. Certainly no Geal Charn can match a Torridonian giant but that just offers a greater challenge for the photographer.

Today we expect pictures to capture the magic. Postcards were, are, a good yardstick. Any display today is attractive and Colin Baxter more than anyone else revolutionised the genre, half a lifetime ago now it feels.

Mountain landscapes suddenly became inspirational through the eyes of photographers like Colin Baxter and Colin Prior. But could today's world of camera and technicalities even be imagined a decade ago? Nevertheless great photography still means being out there, up there, the eye of the camera only the servant of imagination's eye. Alan Gordon stands in a long line of highly-regarded names (like Banquo's progeny seen by the witches), as far from Poucher as Poucher is from George Washington Wilson.

When I recently read the twenty seven books (and much else) of Seton Gordon for an anthology I was struck by the hard graft of all he undertook. He could spend season after season on some subject. He no doubt received the same questioning as Alan, 'How do you always have such superb conditions for your pictures?' and no doubt gave as wry a reply. What you don't see are the hours when the shutter never clicks; shivering in a winter bivouac waiting for a sunrise that does not materialise, seeing a view suddenly disappear in claustrophobic cloud, distressingly dealing with what the BBC forecaster once called 'showers of a continuous nature', constantly climbing thousands of feet to return with nothing. However, this is balanced by the thrilling moments when the magic works and the seeing eye creates the rather wonderful thing that is a photograph.

Running through these pictures is the elusive Peter Pan effect of light, as difficult to define as to describe. Without it the big landscape can go into mourning. I've often thought it has much to do with our mountain world being so watery. After rain the landscape can glitter or, evaporating into cloud, create cloudscapes which can match lapping seas or inland lochs.

Sunrise from the Saddle, looking east along the south Kintail ridge.

Capturing this elusive world gives the photographer fascination and frustration in equal measure, but patience is generally rewarded as our weather is kaleidoscopic rather then static.

This collection is unusual in the mountain world being seen from on high, a landscape probably less affected than any since the last Ice Age receded. There are no great lochs or trees to soften or frame the views (and make photography easier), on the other hand the panoramic format suits it well. Don't we, on any summit, turn and turn, taking in the world with such sweeping study (assuming we can see anything)? The panoramas also take us through the swing of the seasons, from the aching cold of winter to the unambiguous clarity of summer, from the bairn-freshness of spring to the burning reds and browns of autumn. No two days on the hill are ever the same.

As a boy I used to keep my eyes on the ground as I neared a summit and only on arrival looked up for the shock of being overwhelmed by the encircling scene. I still do this (second childhood no doubt!) and looking through these pictures I was constantly given that same *frizz* of excitement.

These are mountain views on a grand scale but they also give intimate foregrounds, not posturing figures in the latest fashions but the delights of nature's small details: lichen patterns, sculpted granite, sun on wind-curved grasses, footprints over blue, crystal snow. This is art and craft combined – the beauty of watching a sleeping cat rather than a hyperactive puppy.

We are not being fed with guidebook coverage, there is no categorising or defining of the hills, just choice moments of being there, dawn or dusk, high summer or deep winter, on a fairly random selection of mountains, many the great and the good which we all hold dear. Here, for us, is recognition, inspiration, anticipation.

Though the landscapes are dramatic, whether in Dürer sharpness or working through the vagaries of weather, ours is a landscape of distress.

We, the great ecological vampires, have sucked away so much of its life, using and misusing it through millennia for our own immediate demands. We are not harmonious beings so we should not be surprised at the history of burning and overgrazing that have left so much wet desert, though today an increasing number of people of vision are seeking the good of the landscape for itself. John Muir was in the vanguard and the John Muir Trust has the like vision that we need to care for our distraught planet, difficult though it proves. As John Muir said, 'To obtain a hearing on behalf of nature from any standpoint other than that of human use is almost impossible.' We need the unfettered solitude of the mountains, we need nature's munificence to balance the big-booted hurts of life. Walt Whitman's cry is ours: 'Give me again, O Nature, your primal sanities.'

Unimaginative developments are no blessing. Superimpose wind farms on any picture in this book, if you would consider the reality of that threat. These pictures may be a record of a world we'll lose, the more sadly because most economic arguments are spurious: the biggest money input in the Highlands and Islands comes from those attracted to it for recreational purposes, among whom are all those who seek this upland world. Pray they never strike oil in Glen Dessarry.

We cannot look back to a period of perfection, but what we have is of vital importance, offering a balancing tranquillity so absent in modern life. We go to the hills to be blessed, to find rejuvenation in that constant, yet always changing world of stone and tree and water, of sun and storm and snow, of wild winds and plaintive plover's call. The tiny figures in a picture of the Storr Rocks not only give scale to that weird feature but hint at our rightful place in the scheme of things. A book like this shows that we do still aspire, we do still dream – and can put feet to our dreams.

Hamish Brown

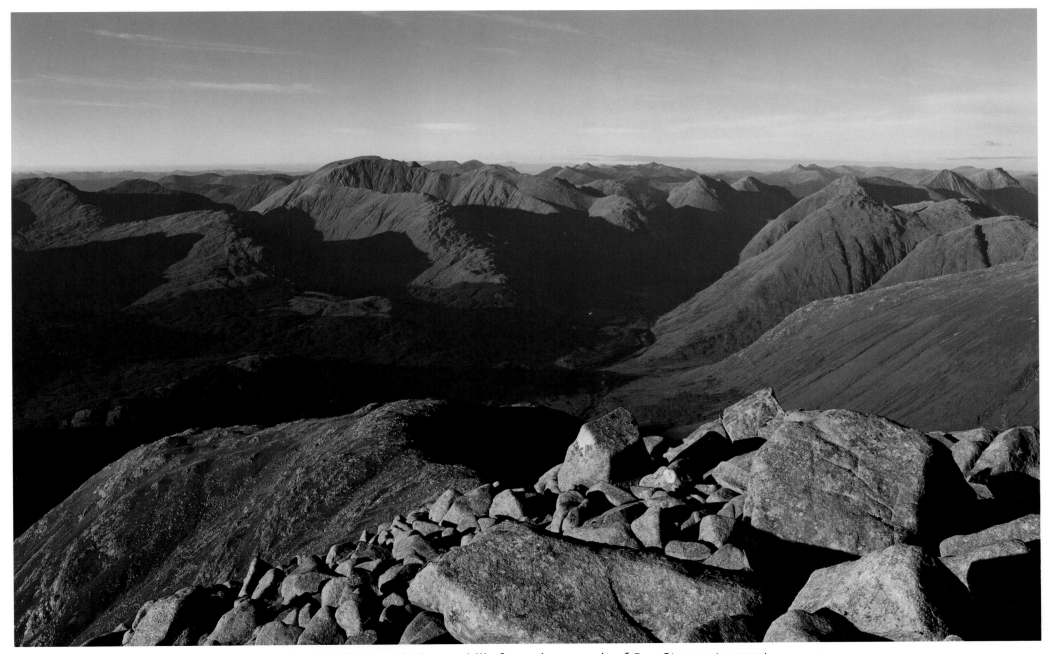

The Glen Etive and Glencoe hills from the summit of Ben Starav at sunset.

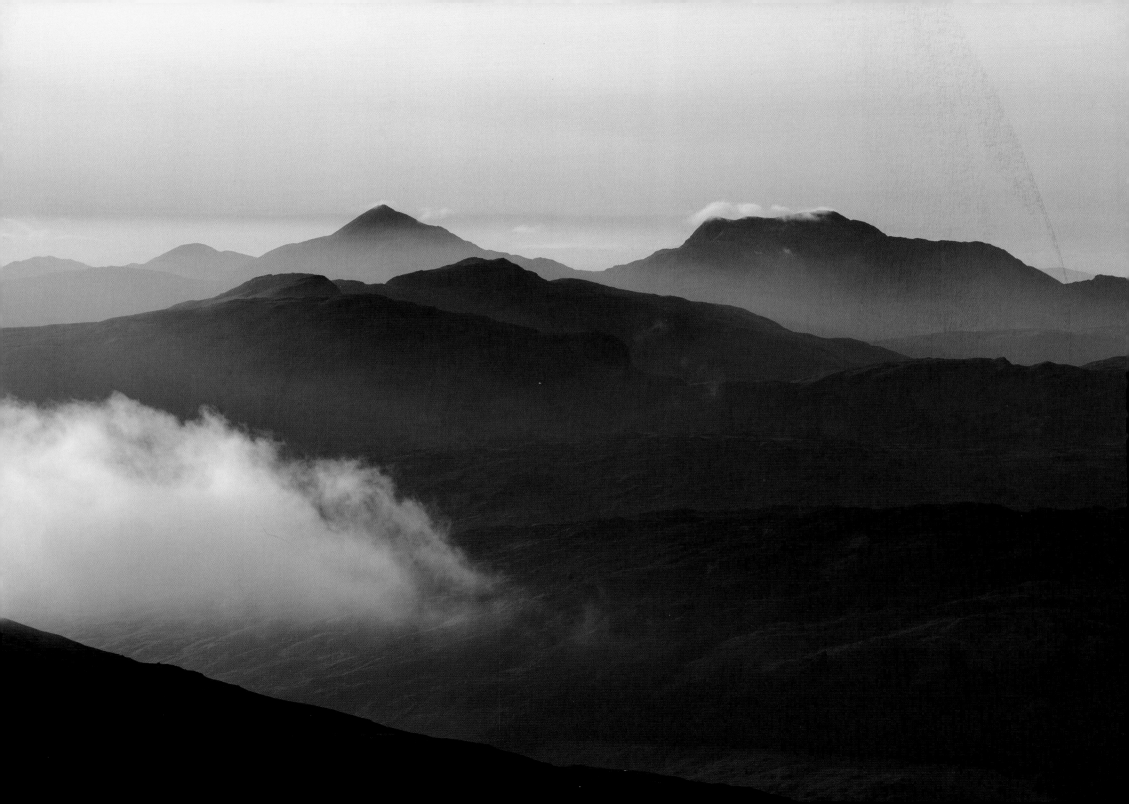

The Sweep of Southern Hills

Sir Walter Scott has much to answer for. His long poem *The Lady of the Lake* started an invasion of the Trossachs by enthusiastic tourists. This was due to timing as much as anything. Ben Lomond already was (and remains to this day) the most frequently climbed hill in Scotland, but still considered a great adventure in those days that saw such a change of attitude to mountains. Earlier, Dr Johnson thought them 'hideous' and when Boswell pointed out a shapely hill, the retort was that it was merely a 'considerable protuberance'.

The yearn to explore, to penetrate the mysterious and pacified Highlands began with accessible places like Loch Lomond and the Trossachs. The Highlands were only slowly discovered and surveyed. Near the end of the nineteenth century (1891) when Sir Hugh Munro produced his *Tables* listing hills over 3,000 feet it contained almost ten times the generally accepted thirty or so in this region. In the 1980s the Ordnance Survey would correct the height of a hill in the middle of Perthshire by 400 feet. The sweep of the southern Highlands is still probably the region where most Lowland inhabitants will make their first forays on discovering the lure of the high places.

From a friend's house in Perth, the Highlands form a striking wall of mountains rising abruptly from the more domesticated foreground. This band runs from horizon to horizon, a real mental as well as physical barrier in olden times. The geologists call it the Highland Boundary Fault. To the hillgoer, Perthshire is the region of green, bulging hills, sheep country, scabby with the contorted rocks of mica schist, boldly spacious, with large lochs and impressive rivers. In Schiehallion it has one of the most romantic hills, in Beinn Dorian the most shapely, in Ben More and Stob Binnein heavenly twins and in Ben Lawers a mountain that was once topped by a cairn to carry it over the 4,000 feet mark.

Loch Lomond still forms both a mental and physical barrier to this day for the sweep of southern hills extends west of that loch into very different country, one riven and moated by long fjords (drowned valleys) and glacier-gouged lochs, Loch Lomond itself, Loch Long, Loch Fyne, Loch Awe to mention the most dominant. As a boy I looked across Loch Goil and from Carrick Castle to Argyll's Bowling Green, a name that fascinated: a super bumpy hill largely smothered in forestry as is much of the area. Ben Lui is however one of the most graceful hills in Scotland and the 'Arrochar Alps' are honoured with their nickname, as is the mischievous Cobbler. These western hills seem harder and they are certainly wetter, while breaking through the defensive forest belt offers a challenge rather special to the area.

One of the joys of walking across Scotland coast-to-coast is having time to absorb the realities of the day by day landscape changes and there can't be greater contrasts between east and west than here. Those brutally beautiful western regions astonish, almost frighten so, as a shepherd once told me, we flirt with the west, but marry the east.

The creation of forest parks, and more recently, one of Scotland's two National Parks indicate the romantic lure of these southern hills is as strong as ever. These are the most exploited hills of Scotland (sheep, fish, trees, hydro, us) and their southern sweep will keep them so.

Ben Vorlich and Stuc a' Chroin at dawn, from Ben Challum.

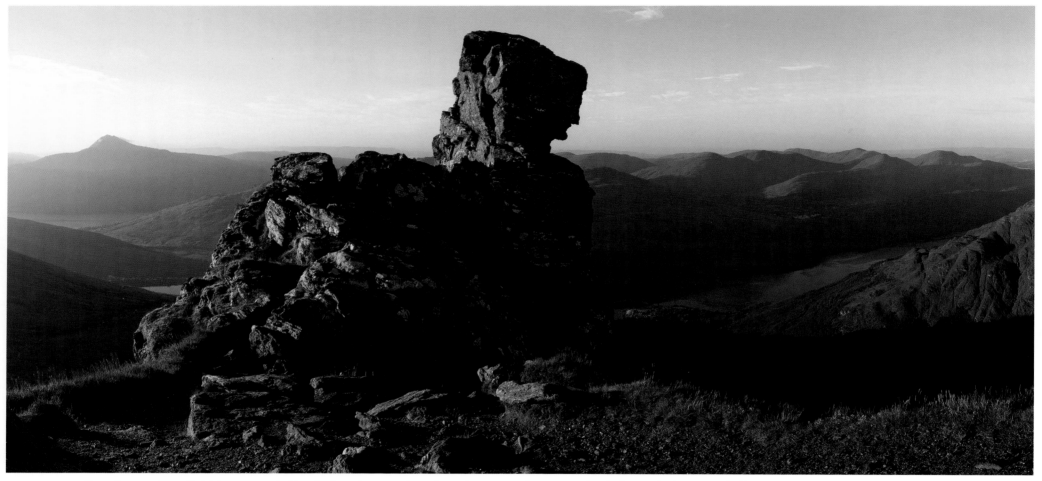

Sunrise on the Cobbler (Ben Arthur). Ben Lomond and Loch Lomond are on the left, and the Luss hills on the right above Loch Long.

Cloud drifts around the summit of Beinn Ime, at 1011m the highest of the Arrochar Alps *(opposite)*.

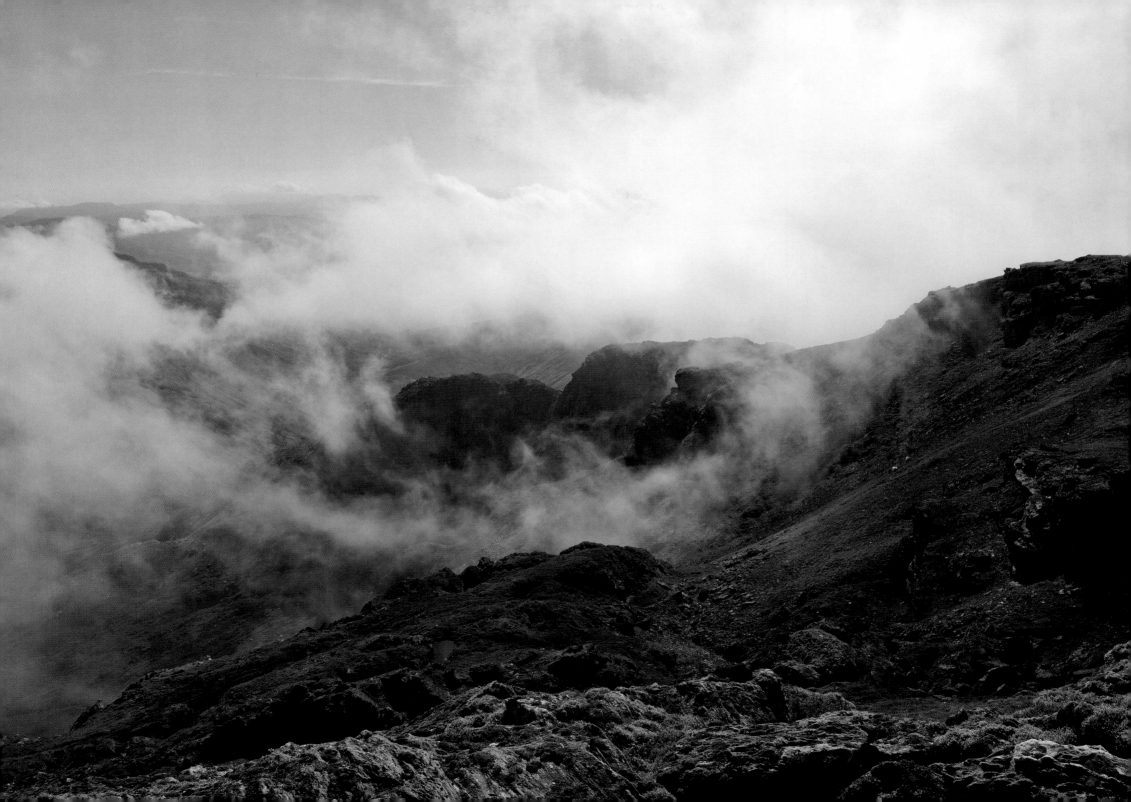

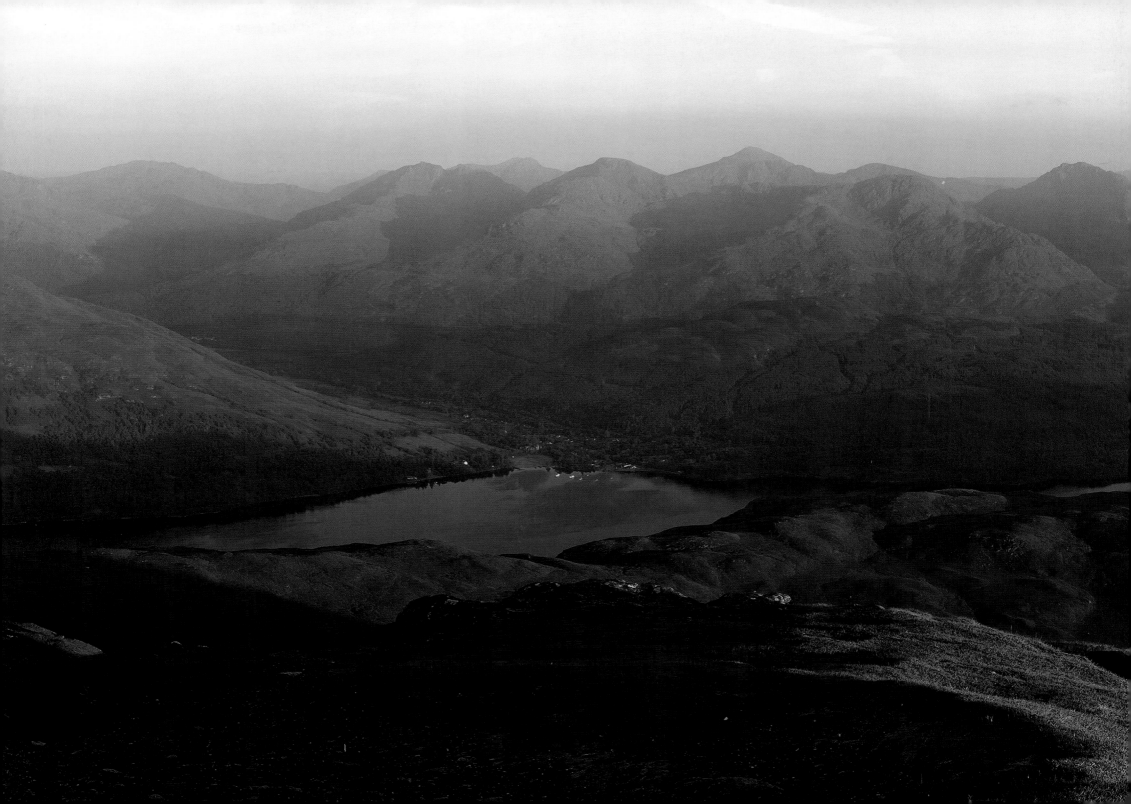

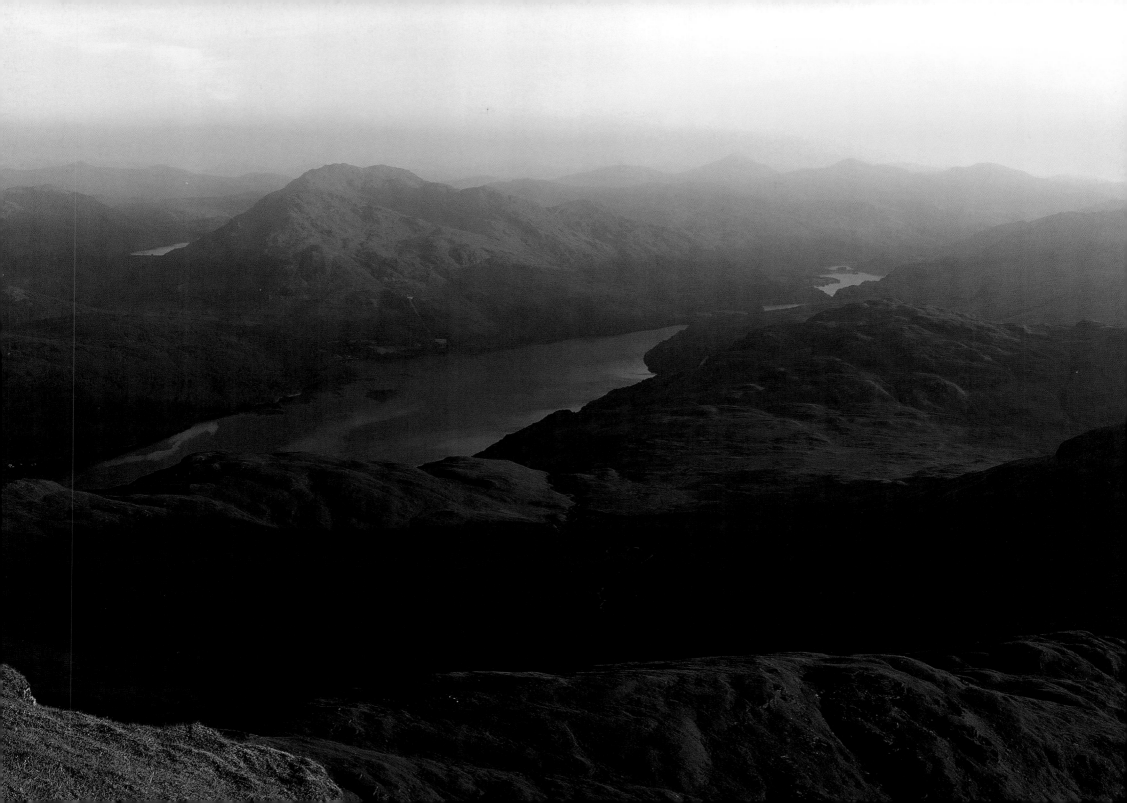

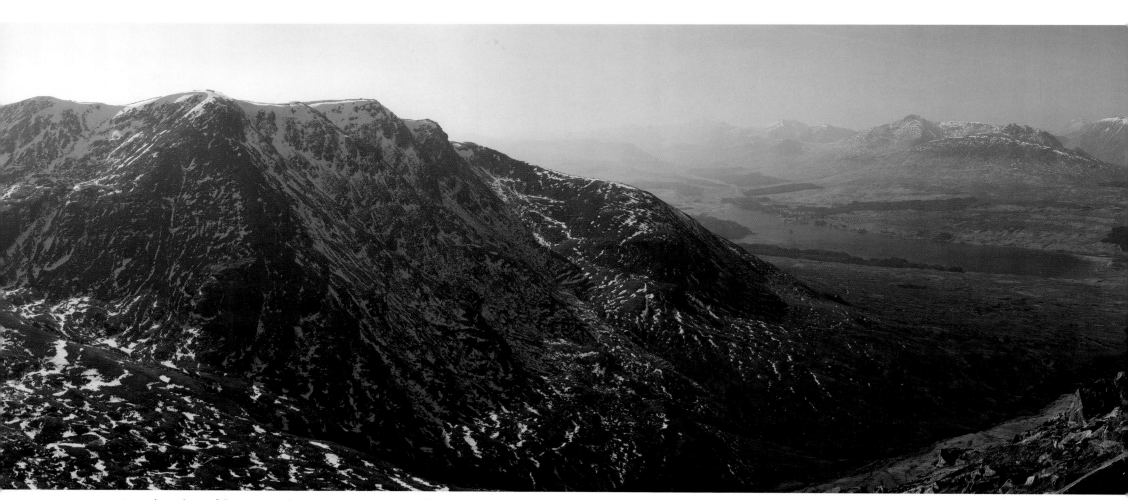

A spring day of hazy sunshine on the Bridge of Orchy hills; Beinn an Dothaidh, Loch Tulla and Stob Ghabhar, seen from Beinn Achaladair.

The Arrochar hills and Ben Vorlich from Ben Lomond at sunrise. The Ben Lui hills are on the right, beyond the head of Loch Lomond *(pages 14-15)*.

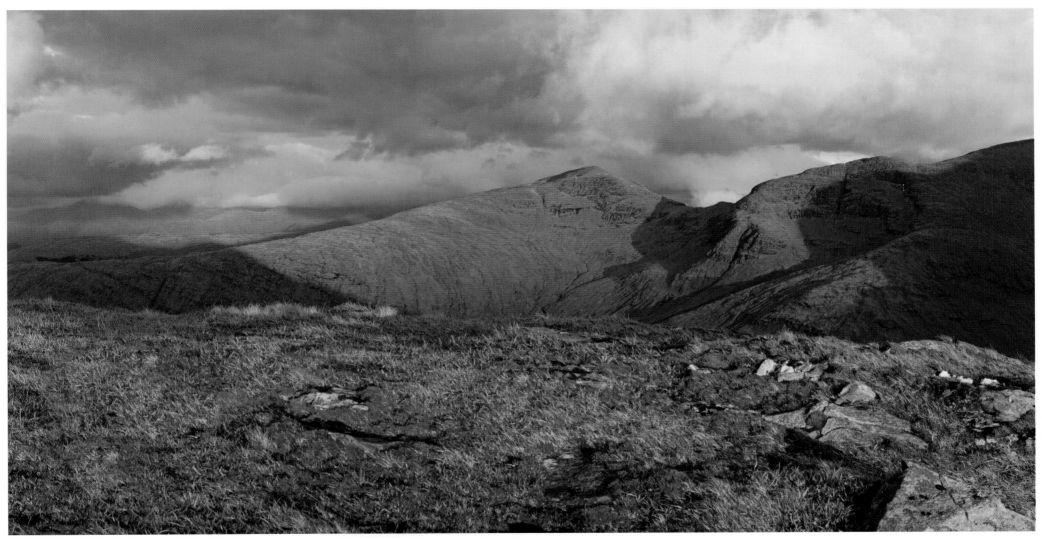

Beinn Dubhchraig from Beinn a' Chuirn at sunset.

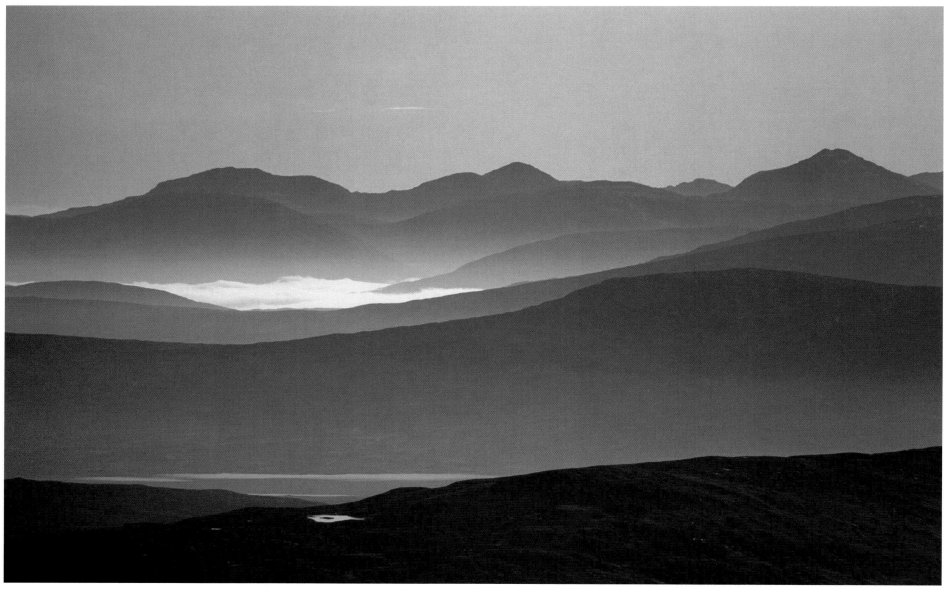

Beinn Dubhchraig, Ben Oss and Ben Lui from the north. A sheet of fog lingers over Rannoch Moor.

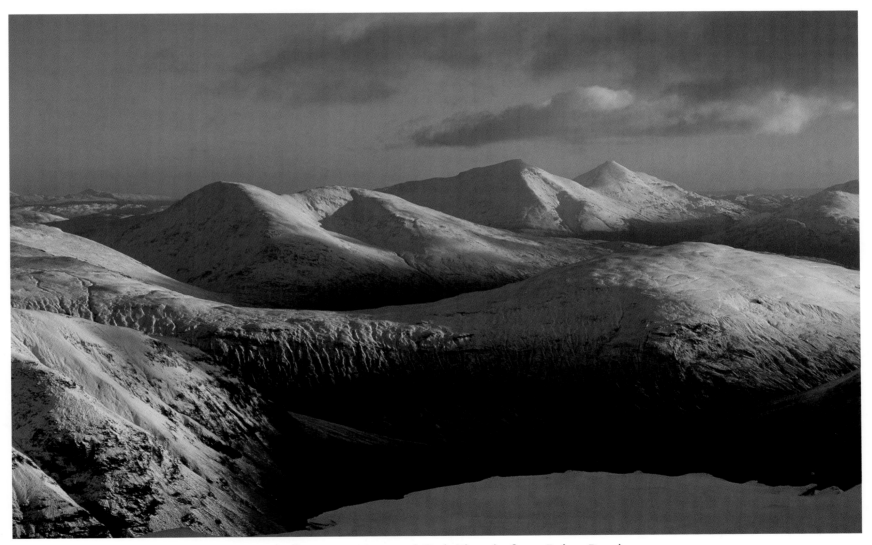

Ben Challum, Ben More and Stob Binnein from Beinn Dorain.

Stob Binnein and Ben More at sunrise, from Stob Coire an Lochain on the south ridge *(pages 20-1)*.

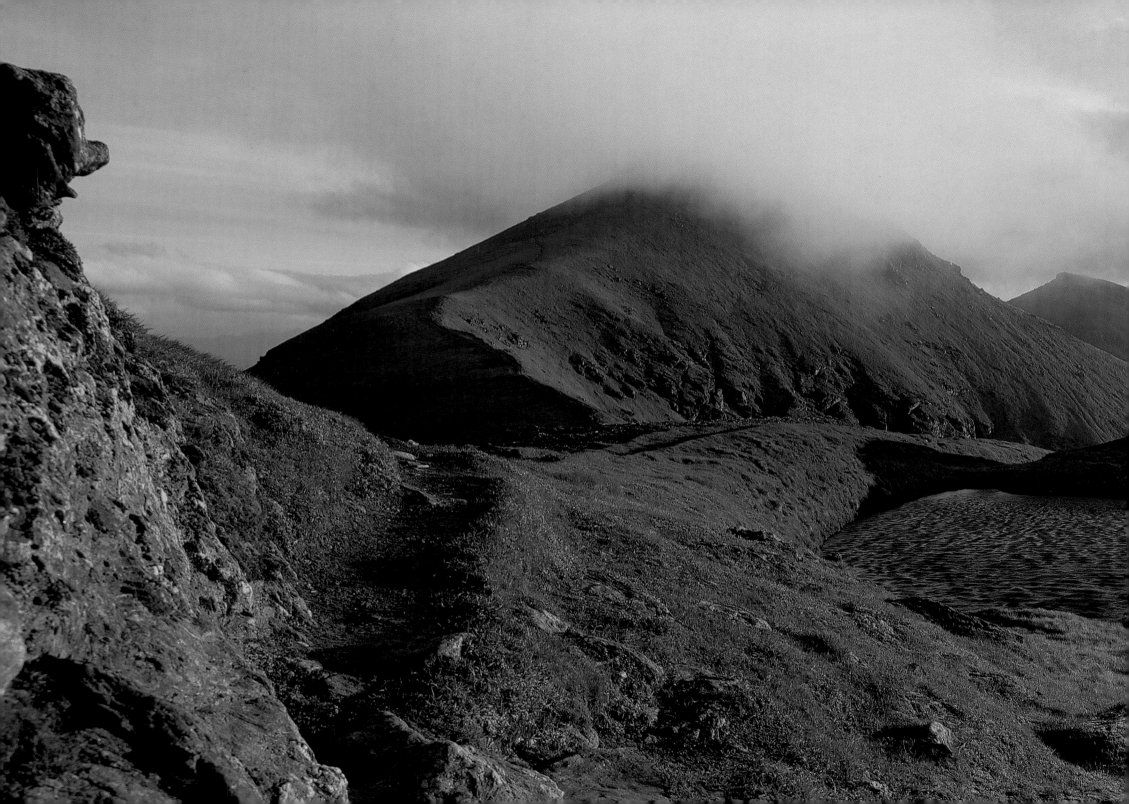

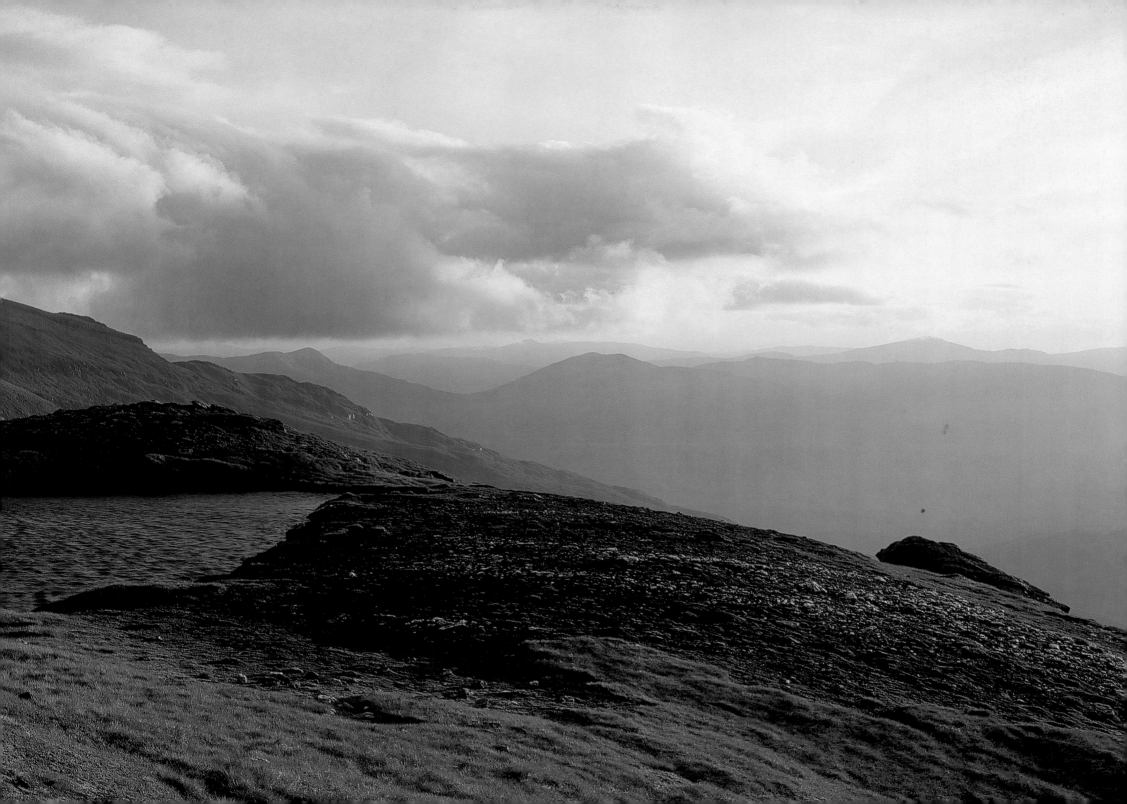

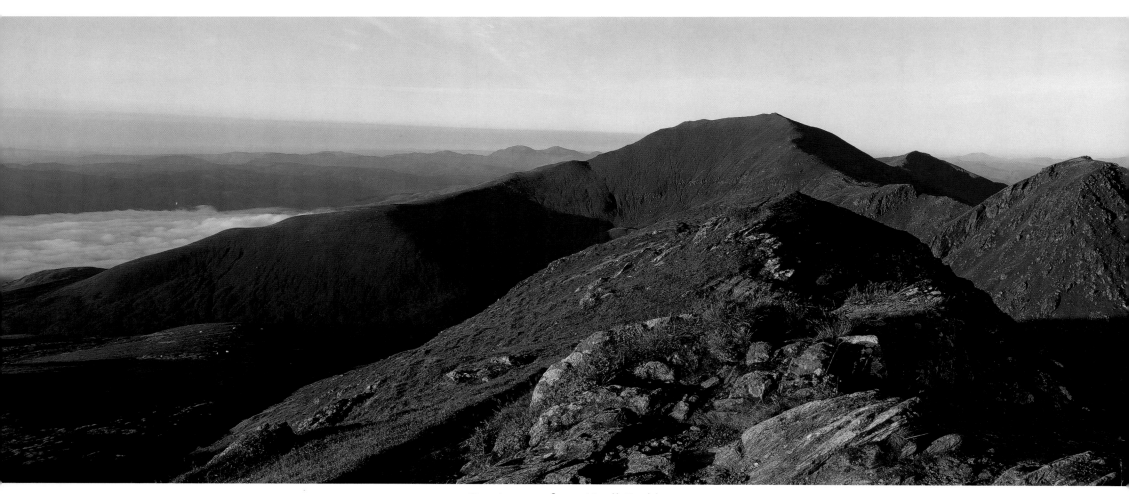

Ben Lawers from Meall Garbh.

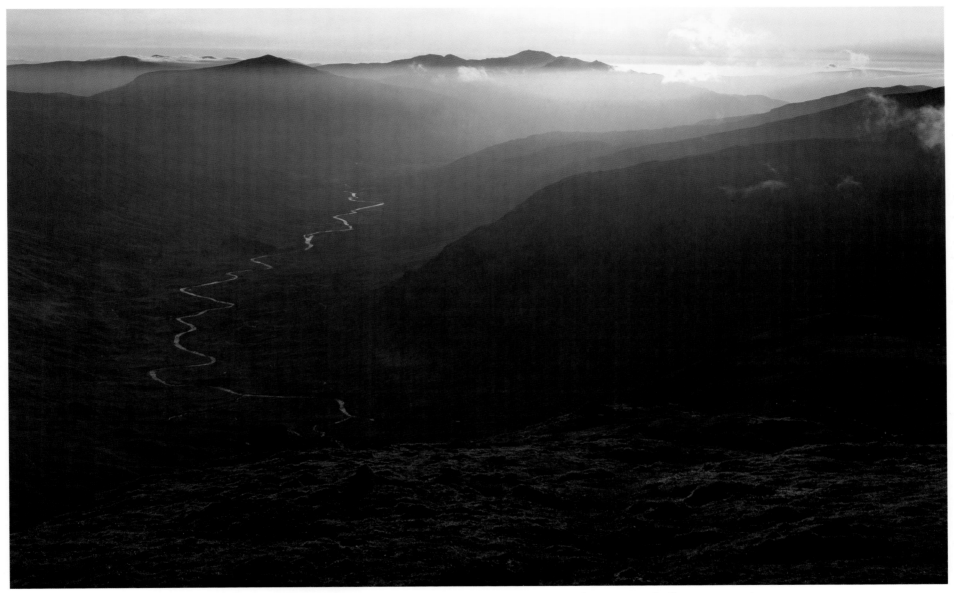

Meall Ghaordaidh, the Ben Lawers hills and the Tarmachans from Ben Challum at sunrise.

The Tarmachan ridge in winter – Meall Garbh from Meall nan Tarmachan *(pages 24-5)*.

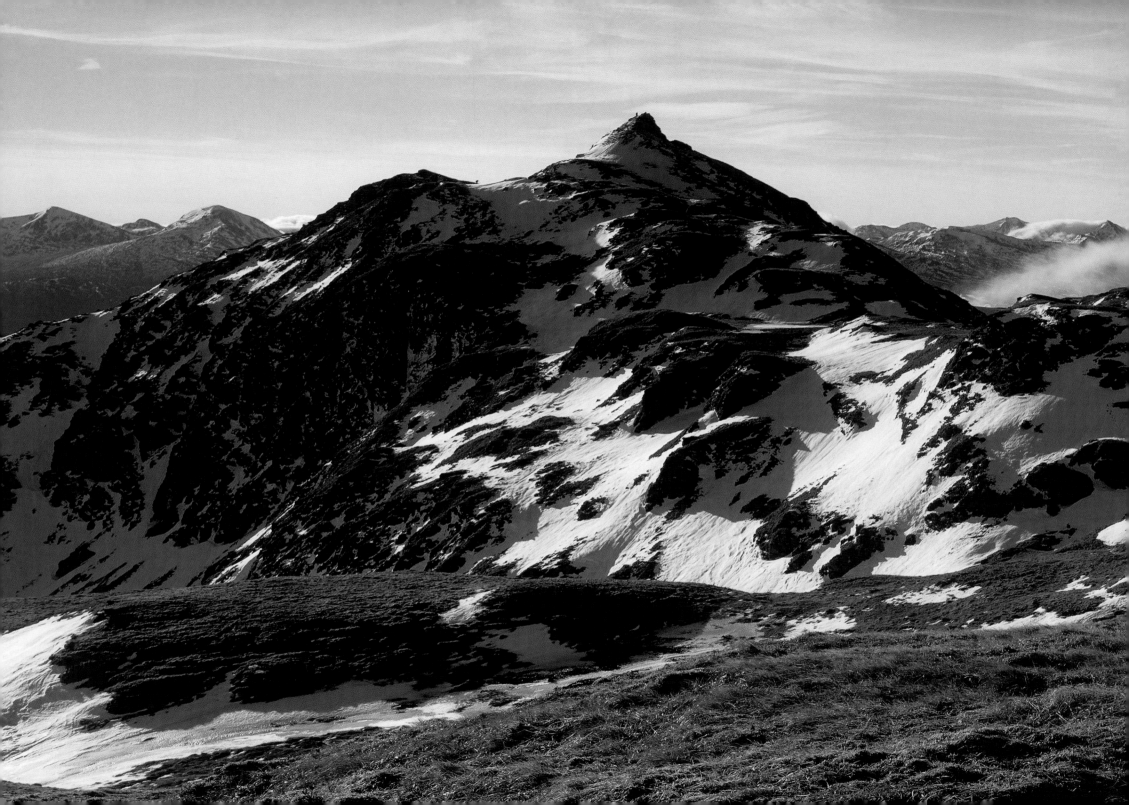

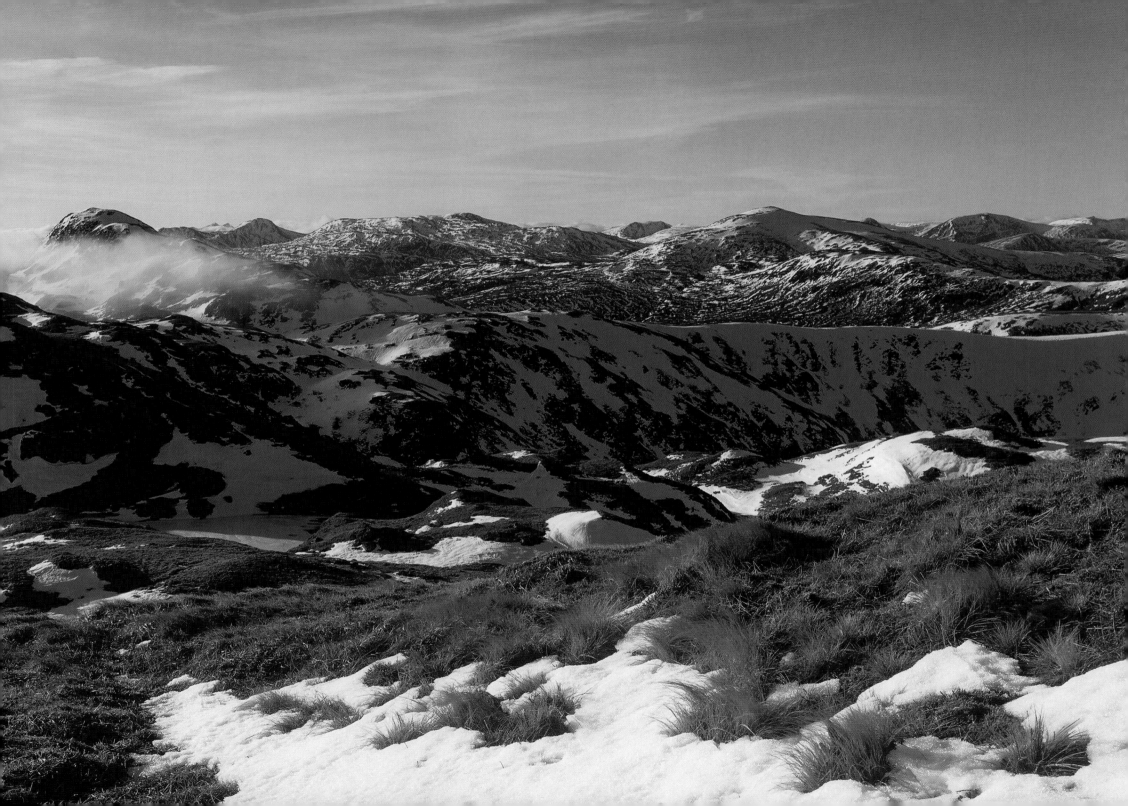

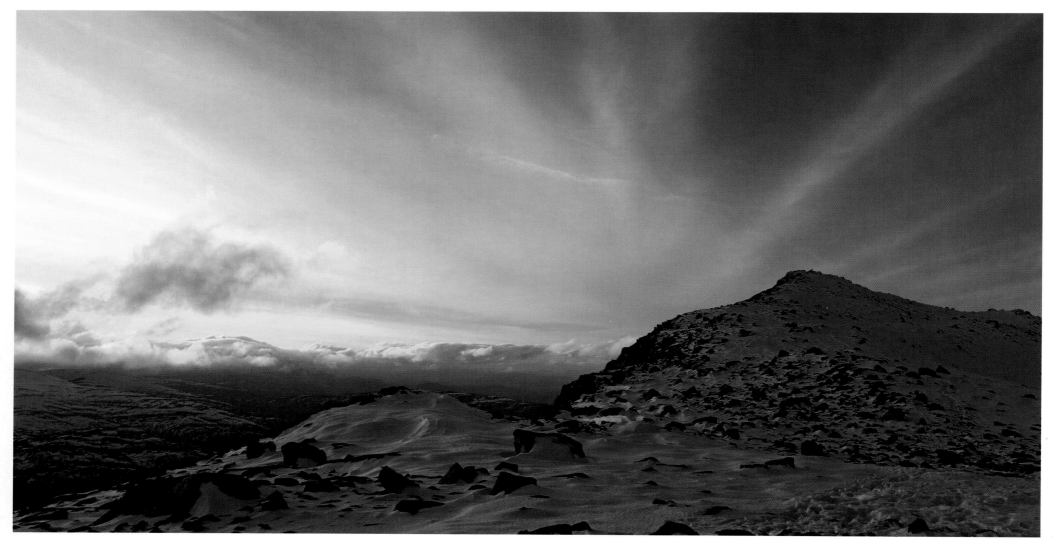

The summit ridge, Schiehallion.

Ben Challum from Beinn a' Chuirn *(opposite)*.

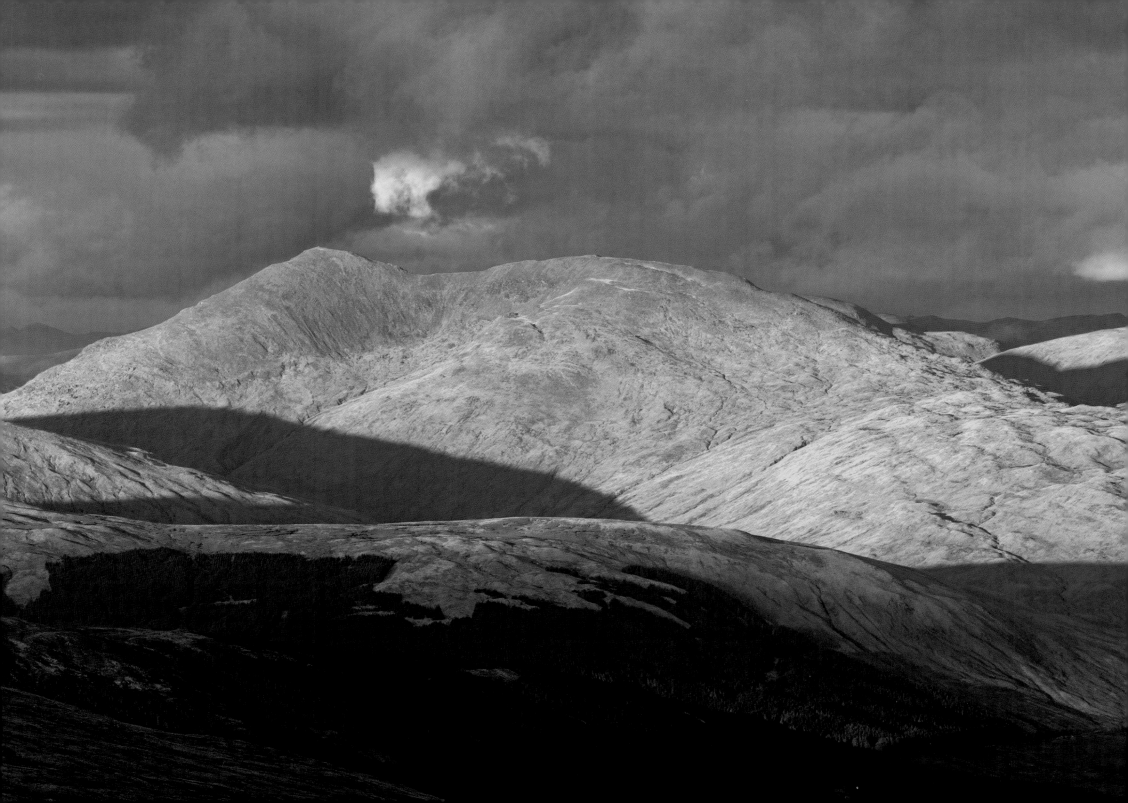

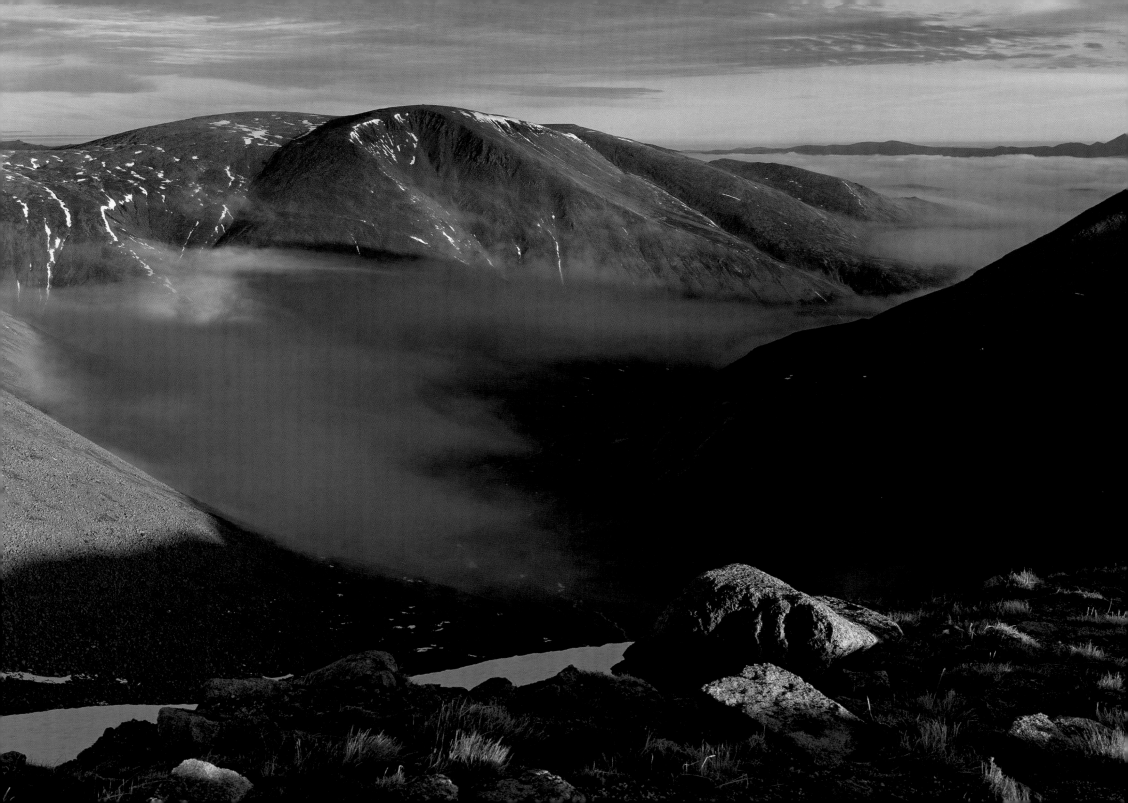

The Confederacy of The Cairngorms

The Cairngorms name is a useful shorthand and I use it at its widest for a confederacy of areas really, which historically was more often known as the Mounth. This bold mountain world stretching across from Drumochter to Stonehaven was a much-feared barrier before Wade and his soldiers built the precursor of the A9. There were no easy ways through. More often than not the name Grampians is printed across most of the area with a randomness arising from its artificiality. The Cairngorms too is a name that is artificial and rather vaguely applied. The hills seen from Strathspey were the Monadh Ruadh (the Red Hills), balancing the Monadh Liath (Grey Hills) to the west. Today the hills of Deeside, like Lochnagar, are taken into the Cairngorms confederacy.

The creation of a National Park indicates the special nature of the area. With five hills over 4,000 feet (Ben Macdui, Braeriach, Cairn Toul, Sgor an Lochain Uaine, Cairn Gorm) and the plateau-like nature of this granite world we have a unique arctic-type landscape. J C Milne once wrote, 'Fecht for Britain? Hoot awa! / For Bonnie Scotland? Imph, man, na! / For Lochnagar? Wi clook and claw!' It's that sort of place.

Much of the Cairngorm heartland is the red granite of the *ruadh* name, forming barren plateau with scant vegetation, windswept, shattered by frost, carved into by glacial corries and the great passes of the Lairig Ghru and the Lairig an Laoigh and Glen Tilt. It has a tenacious arctic / alpine flora and wildlife and weather that can be beyond belief in its violence, as regular fatalities indicate. In summer the tops may sprawl under blue skies so even their remotest summits are a joy, but the featureless miles can be ambushed at any time by the sort of storms more common at the Poles. They are not tame mountains.

The distances demanded of walkers are long and lonely. I once fell asleep in the heather below one of the great corries and woke to the tinkling of a bell – and found a reindeer gazing down at me. I thought I was hallucinating. Looking back now they were the first of the wild creatures driven to extinction by man that have since been reinstated. And if Loch an Eilein saw the osprey vanish, Loch Garten has seen its happy return to become the very symbol of the Cairngorms.

Here too are Scotland's greatest areas of remnant, and supplemented, forest of Scots pine, the Cairngorms lowland glory – not all that low either, Loch Morlich lies over 300 m (1000 ft). Crested tit, greenshank, blackcock, capercaillie are the birds of this world. Ptarmigan, golden plover, dotterel, raven, golden eagle, are the birds of the high Cairngorms. Seton Gordon tramped miles to make the first photographic study of eagles and his *Cairngorm Hills of Scotland* (1925) is still a prized work. When I edited the anthology *Poems of the Scottish Hills* (1982) no other area had as many poems written about it.

No major lochs are found in this area and those there are tend to be deep set among great crags or in the lap of the corries. While the highest plateaux are rocky and sandy, elsewhere the rockiness is softened with heather which clothes all the slopes and lower ground. Nowhere else among our hills is one forced to put in the miles to gain any reward. That is the reward.

Ben Macdui from the head of An Garbh Choire, south of the Falls of Dee. An inversion covers Deeside.

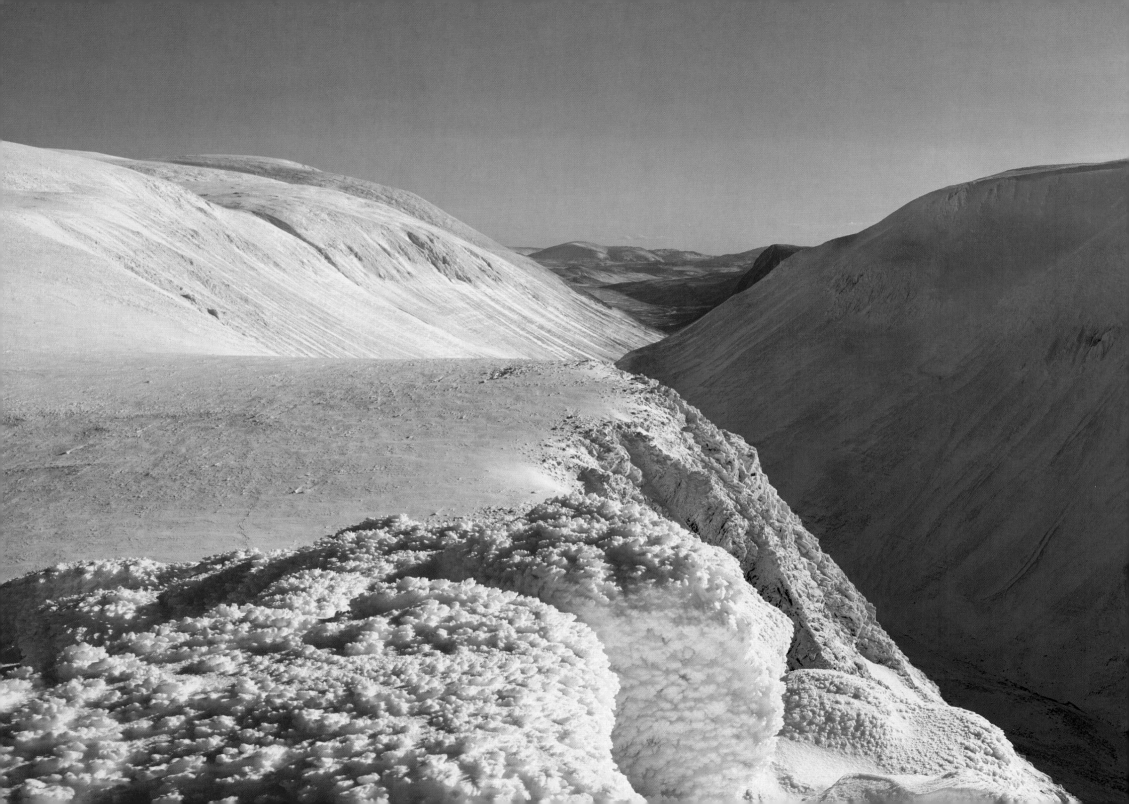

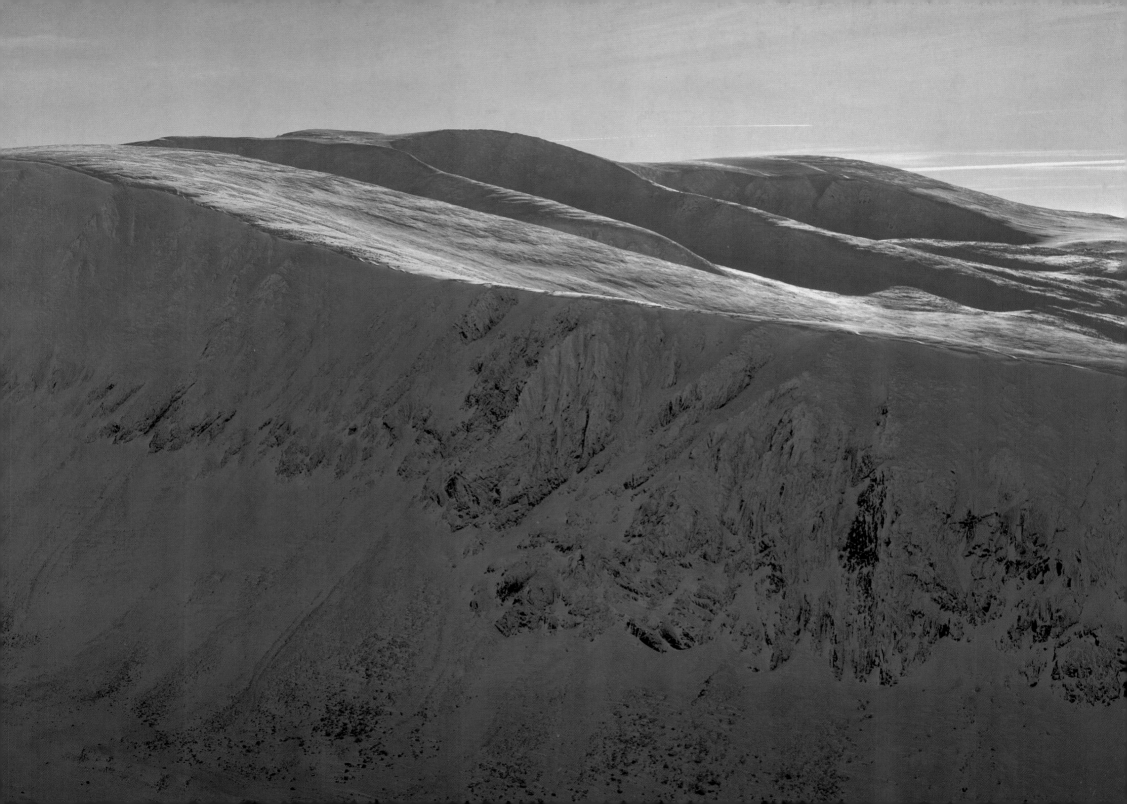

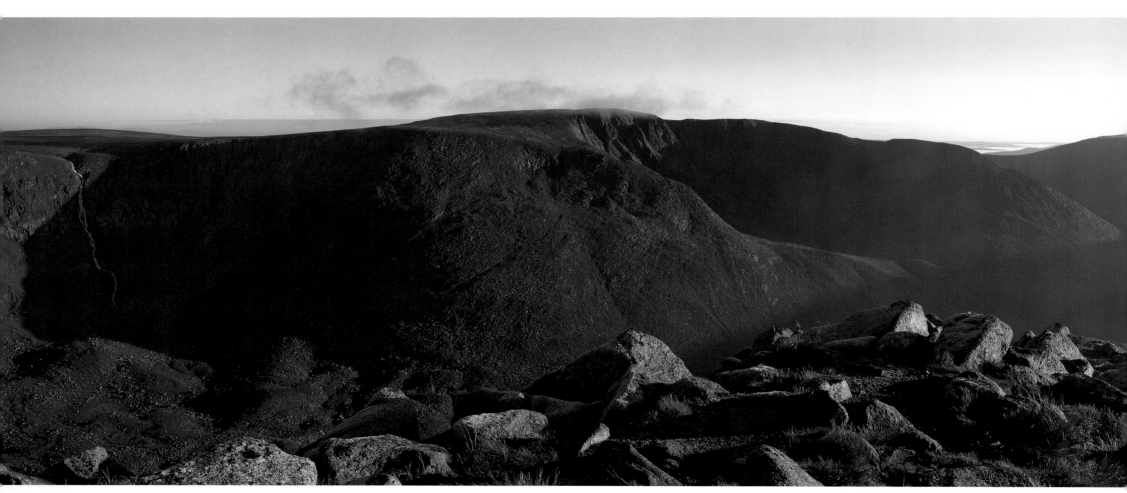

Sunrise on Braeriach, from Sgor an Lochain Uaine.

Looking south through the Lairig Ghru from Creag an Leth-choin. Ben Macdui is on the left and Braeriach on the right *(pages 30-1)*.

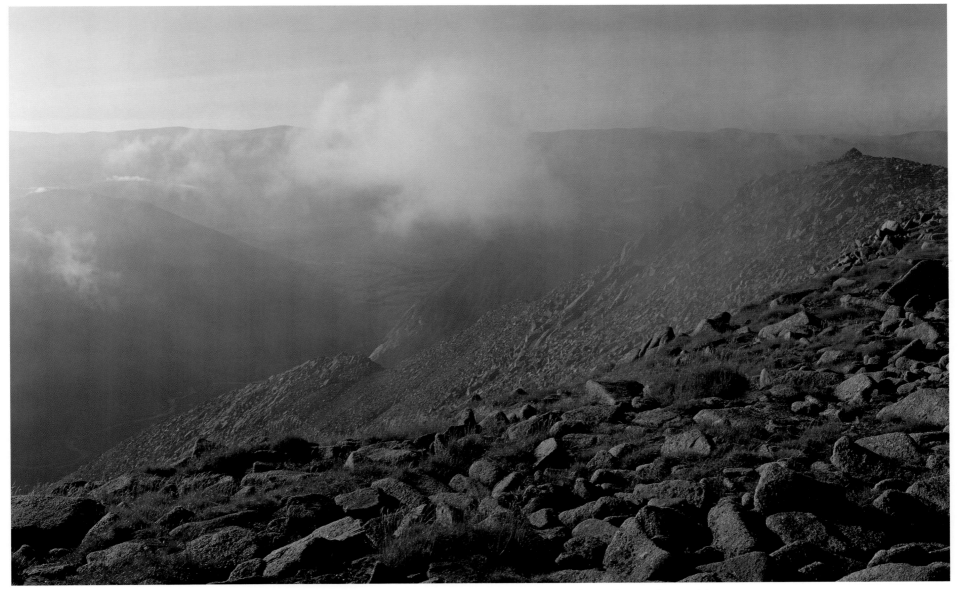

The summit of Cairn Toul, looking south to the Devil's Point and Deeside.

Cairn Toul and Ben Macdui, with the Devil's Point at the foot of Glen Geusachan, from Monadh Mor *(pages 34-5)*.

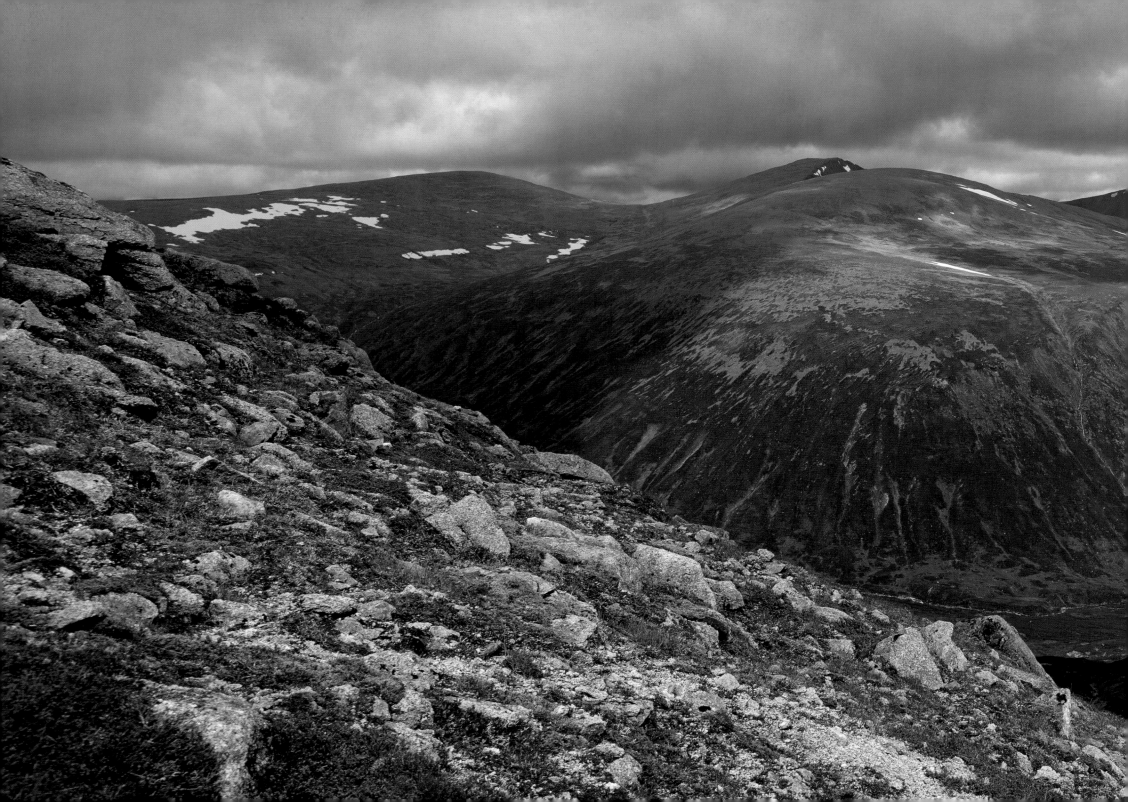

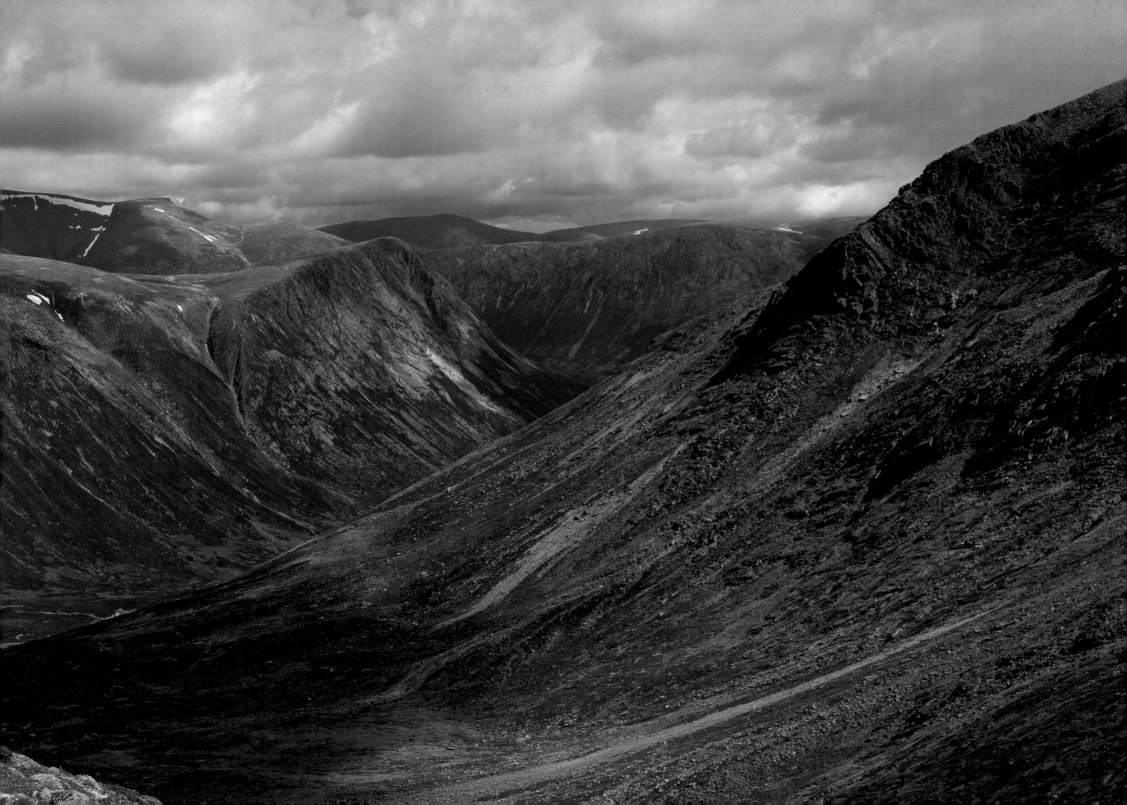

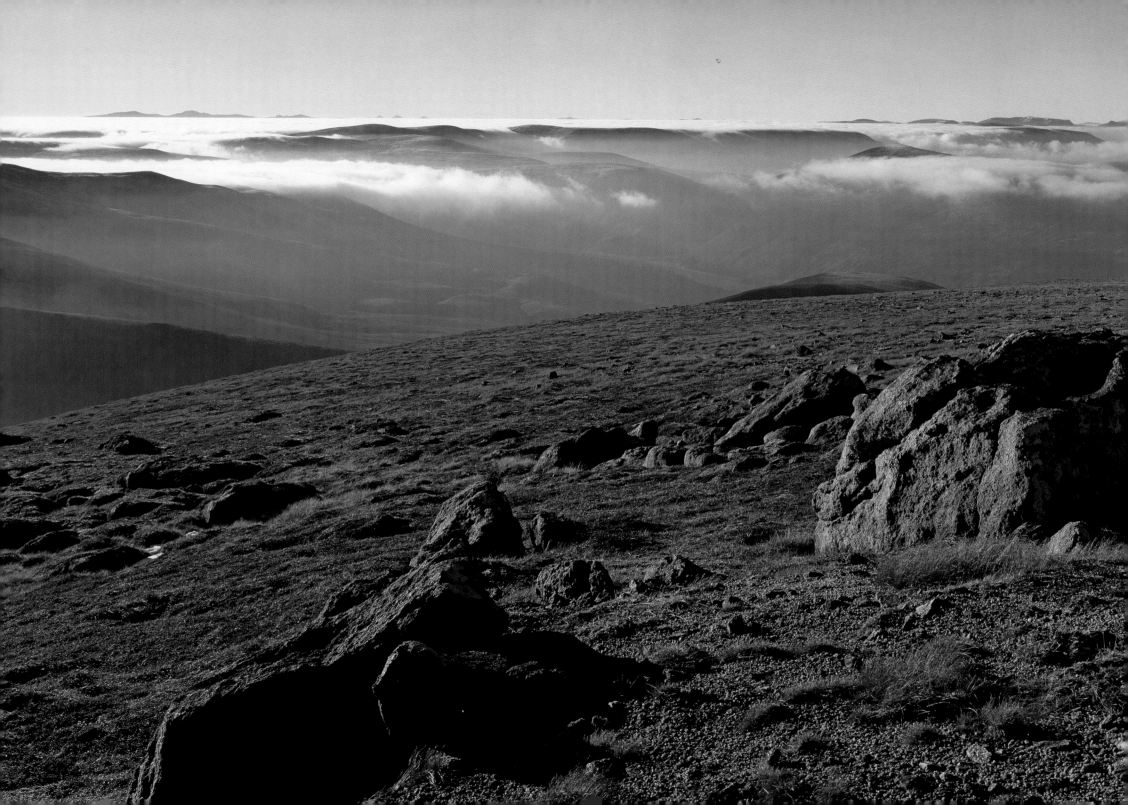

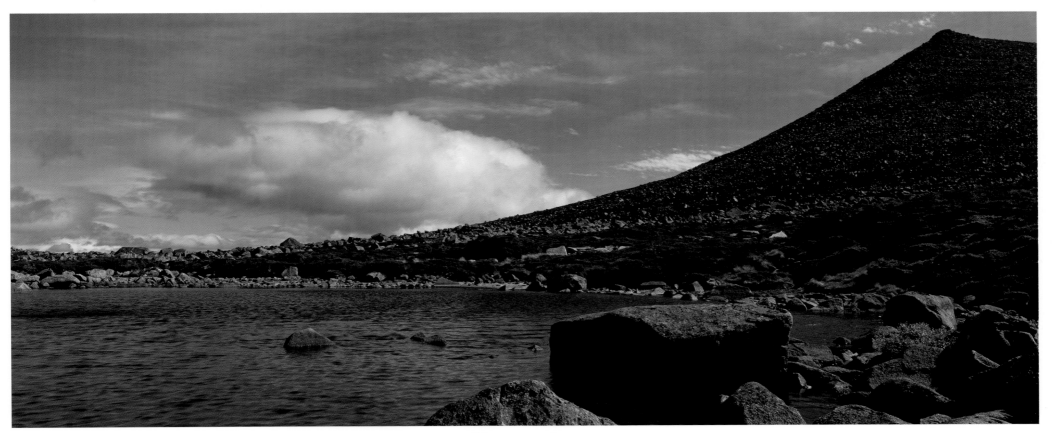

Meikle Pap, Lochnagar.

Seen from Meall Dubhag, a temperature inversion covers the hills to the south and west of Glen Feshie,
with Ben Lawers on the left and Ben Alder on the right of the horizon *(opposite)*.

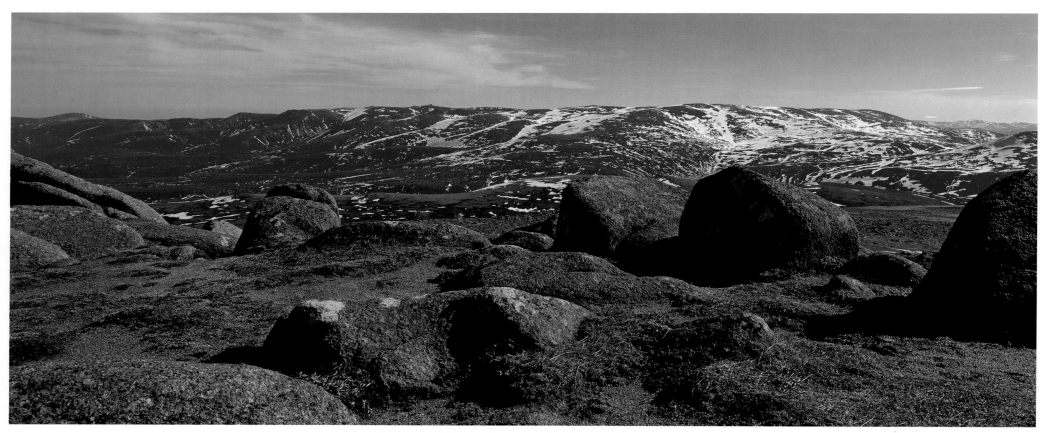

Ben Avon from the summit of Bynack More.

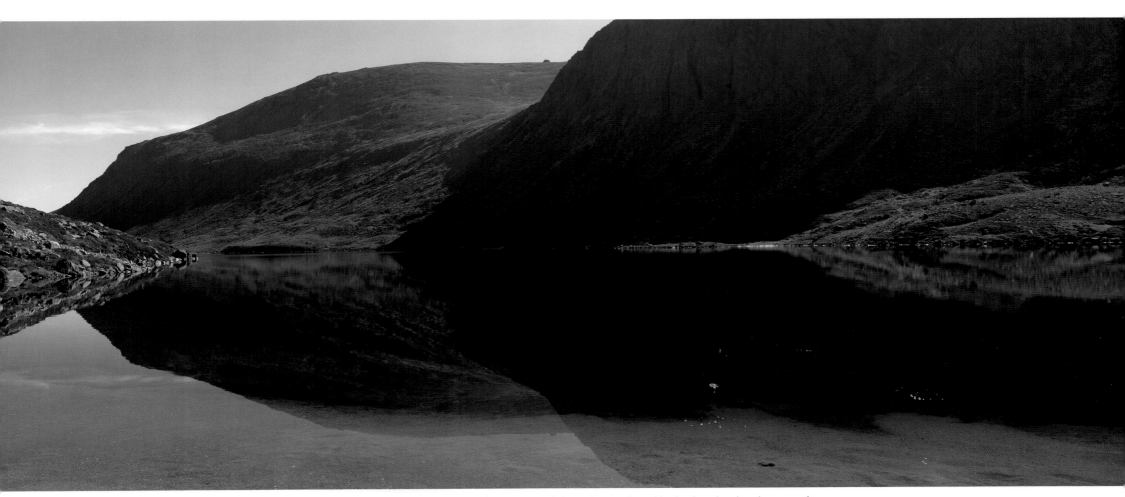

A still summer's day on Loch Avon, with Beinn Mheadhoin in the background.

Cairn Toul, the Lairig Ghru and Ben Macdui from the Devil's Point *(pages 40-1)*.

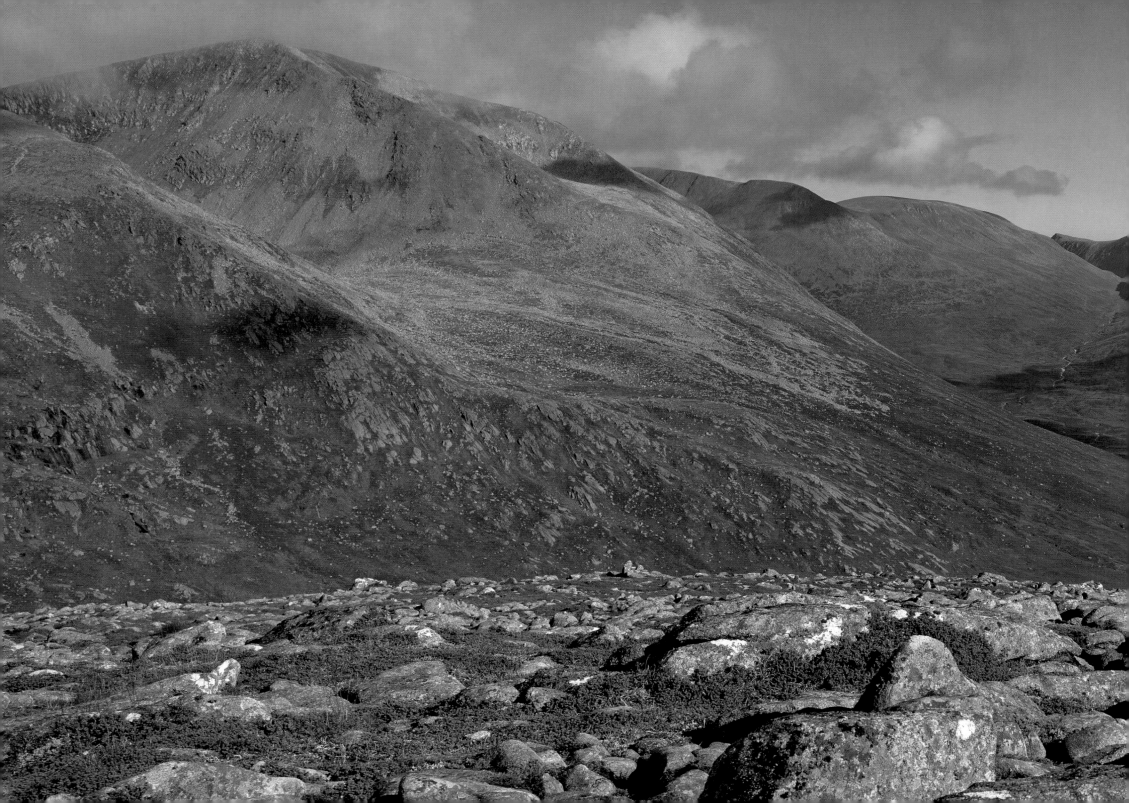

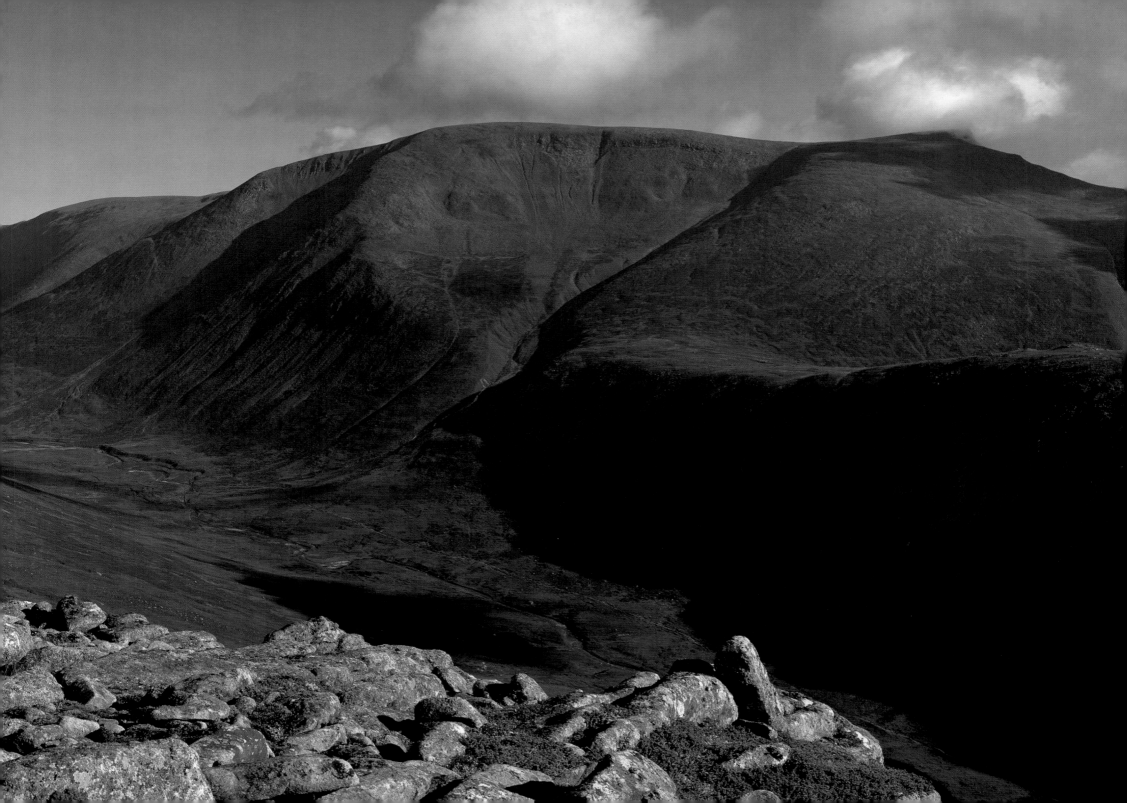

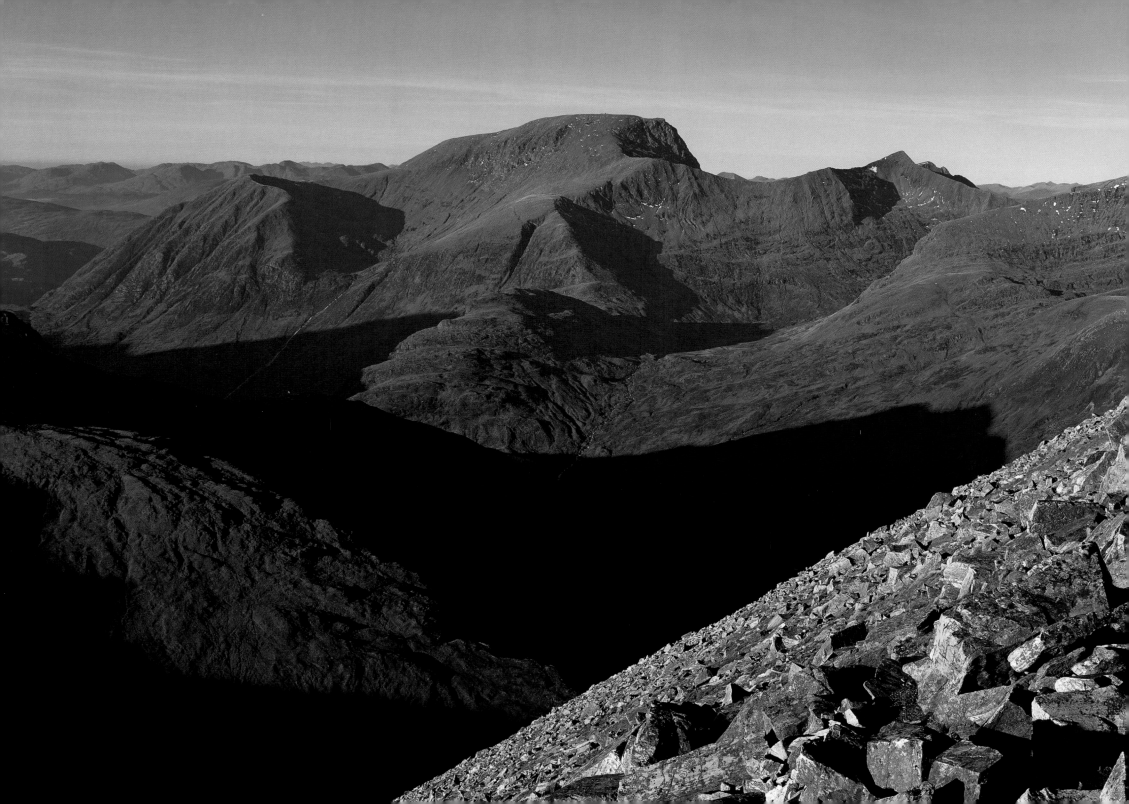

The Central Heartland

An area with Glencoe and Ben Nevis could well be called the heartland of our mountain world. I often feel, driving across Rannoch Moor, with the Buachaille Etive Mor ahead, that I'm entering a different world, very different from what lay behind. There's something of that feeling too on turning off the A9. From Ben Cruachan to Ben Alder is the most challenging mountain area south of the Great Glen. If the Cairngorm range offers miles, this area offers verticalities.

Some of the verticalities are emphasised by hills rising out of sea lochs, the fjord-like sabre cuts of Loch Leven and Loch Etive, and there are other large freshwater lochs. Rannoch Moor may be a thousand feet in altitude but this scarcely takes away anything from the hills that bound its strange world. The Moor's southern slopes drain to Bridge of Orchy, its northern waters head seawards down Glen Etive, but from its higher ground the waters run east to Rannoch and Tummel and Tay. Skeleton bogwood points to this having once been forest. Robert Louis Stevenson sent Alan Breck Stewart and David Balfour across the Moor, the area called poems from G K Chesterton, Naomi Mitchison and T S Eliot, while Glencoe is haunted by its history. Heartland indeed.

Then there is 'the Ben', the very dropping of the 'Nevis' an indication of respect, just as children give a dominant teacher a nickname. Being Britain's highest summit of course (4018 feet before becoming 1344 metres) the hill becomes the magnet for all and sundry. In the height of summer the Tourist Path becomes a pilgrim's trail, and for some, quite a trial. On my first ascent, alone, aged fourteen, I was amazed to see the turn-ups of my trousers full of ice as I stood by the Observatory ruins – in midsummer. The Ben claims as many lives as the Eiger, but then winter climbing on the Ben is of world renown.

But that is partly because one side is rent by the biggest of inland cliffs. From it too arcs the Carn Mor Dearg Arête and Carn Mor Dearg faces Aonach Mor and Aonach Beag (the Beag *higher* than the Mor), the only non-Cairngorm cluster of 4,000 metre summits in Scotland. Ben Nevis thus has many attractions. The Ben Nevis Race record, from Fort William New Town Park to the summit and back, is under an hour and a half. A motor car was taken to the top in 1911 and it has suffered all manner of gimmicks since. Recently a piano was found hidden in a cairn on top – probably carried there over 20 years earlier by a gang of Dundee removal men.

While the Ben does tend to dominate, south across Glen Nevis lies the Mamores, a great string of ten Munros, the best ridge challenge south of the Great Glen. (And if that is not enough you could add the Ben, Aonachs, Grey Corries and the Stob Choires of Loch Treig as some do!). But there are fine peaks galore: Cruachan of the fangs, Starav above Loch Etive, Bidean nam Bian, the highest in Argyll, the Ben Alder heights (another plateau) and Creag Meagaidh, this last lying north of the A86 Glen Spean road and beyond which sprawls the whaleback moors and mosses of the Monadh Liath. On those summits we stand at the heart of things, a splendid geological mix with granite (Cruachan), quartzite ridges (Mamores, Grey Corries), lava cauldrons (the Ben, Glen Coe), slate (Ballachulish), schists and old red sandstone east of Loch Ness.

Ben Nevis and Carn Mor Dearg from Binnein Mor.

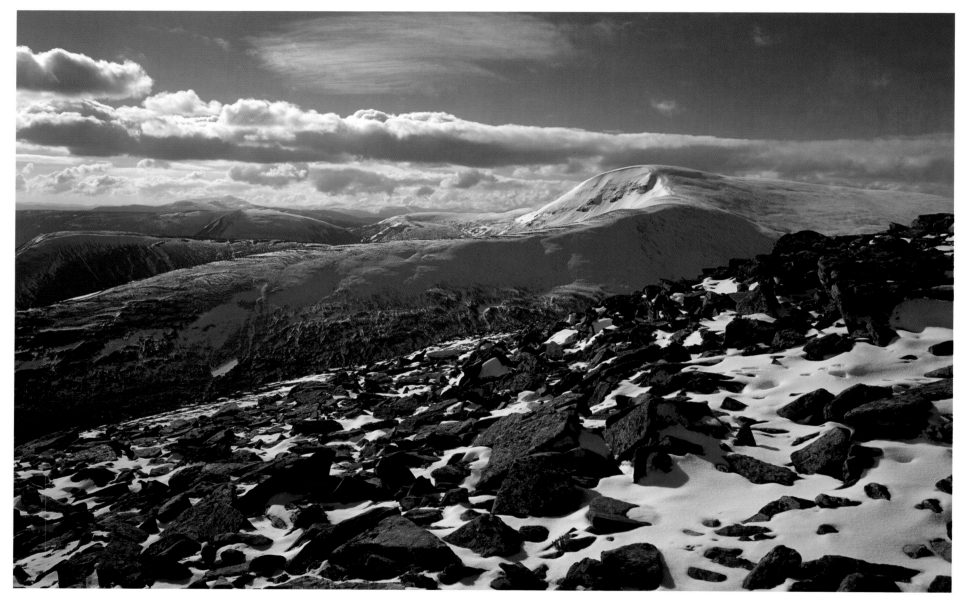

A' Mharconaich from Geal-charn, in the Drumochter hills.

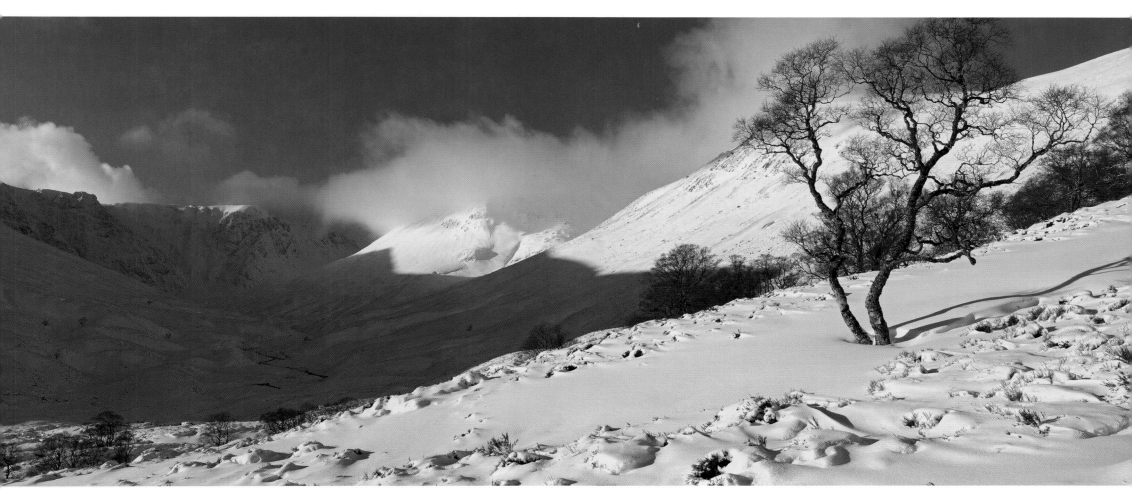

The cliffs of Creag Meagaidh, from Coire Ardair.

Stob Choire Claurigh, at 1177m the highest of the Grey Corries, from Stob Coire na Ceannain *(pages 46-7)*.

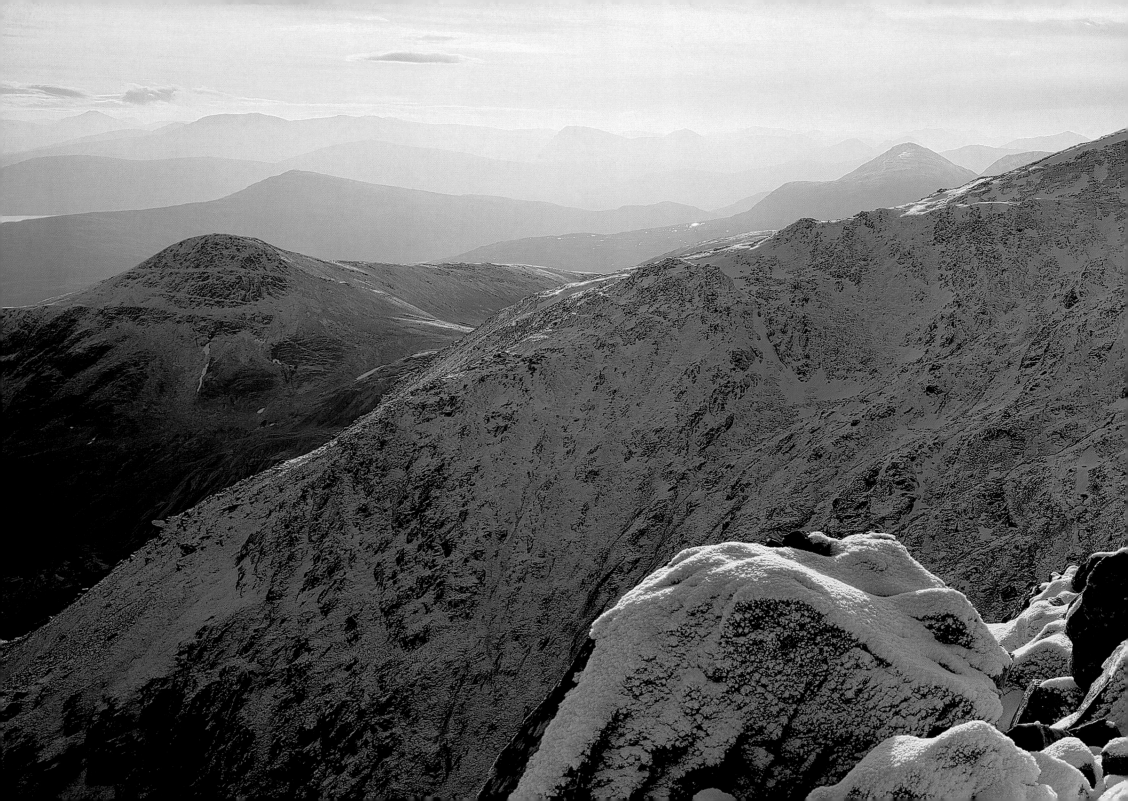

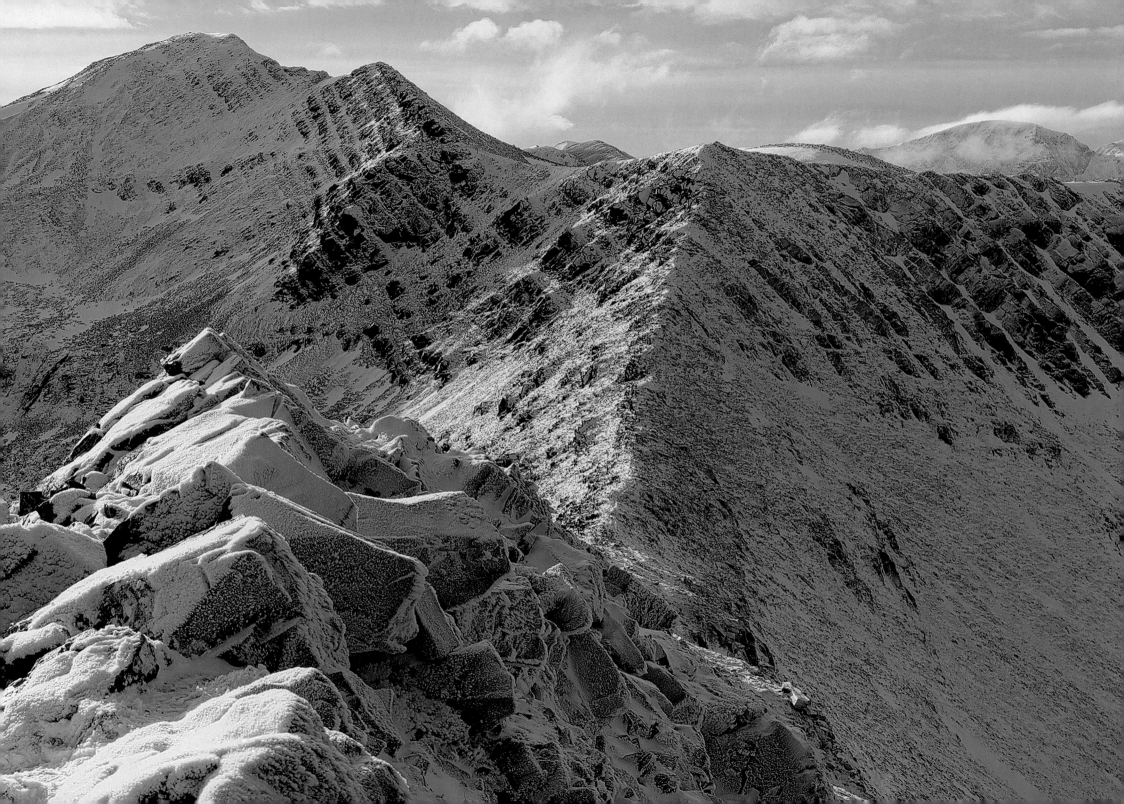

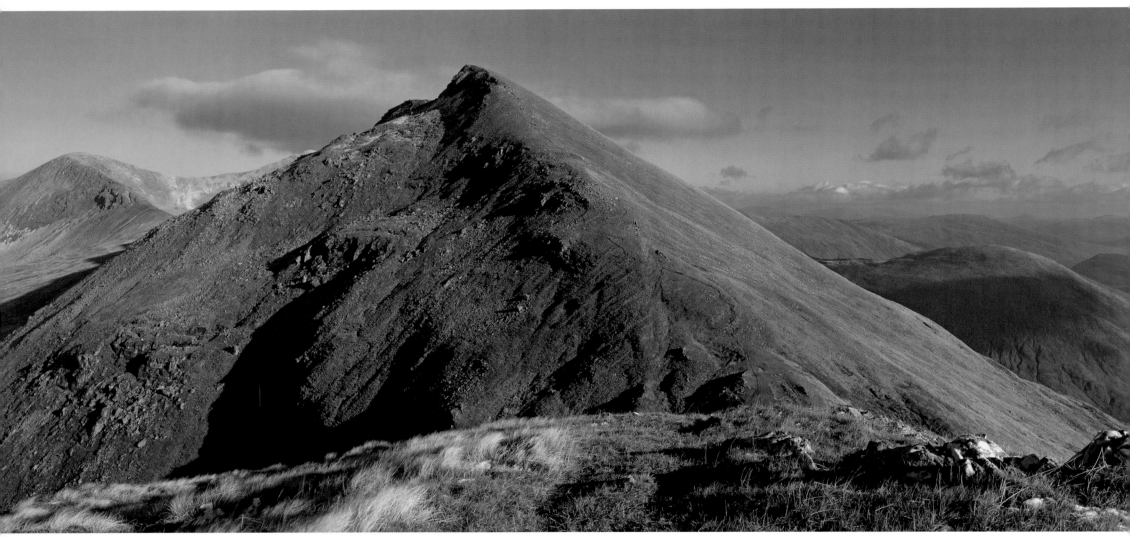

Sgurr Choinnich Mor from Sgurr Choinnich Beag.

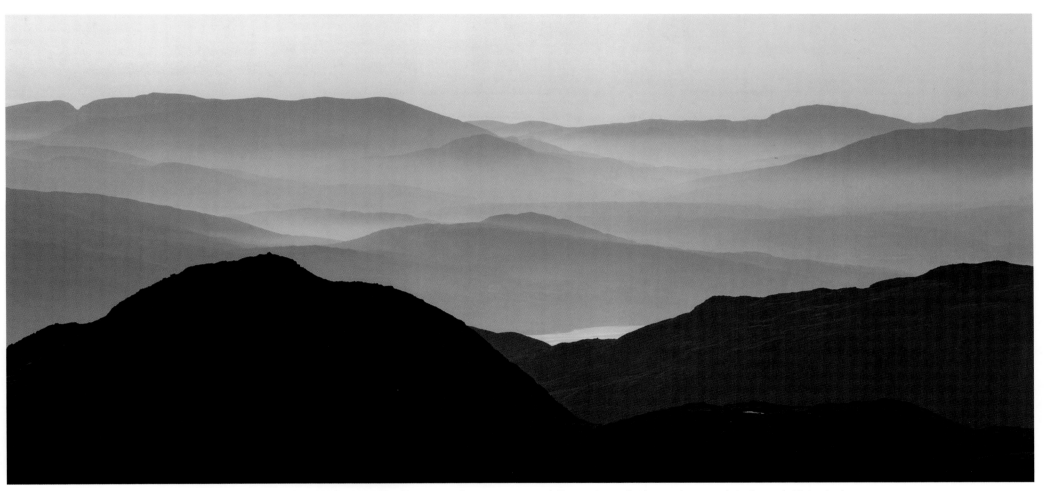

A distant view, from above Glenfinnan, of Creag Meagaidh, Beinn a' Chaorainn and Beinn a' Chlachair.

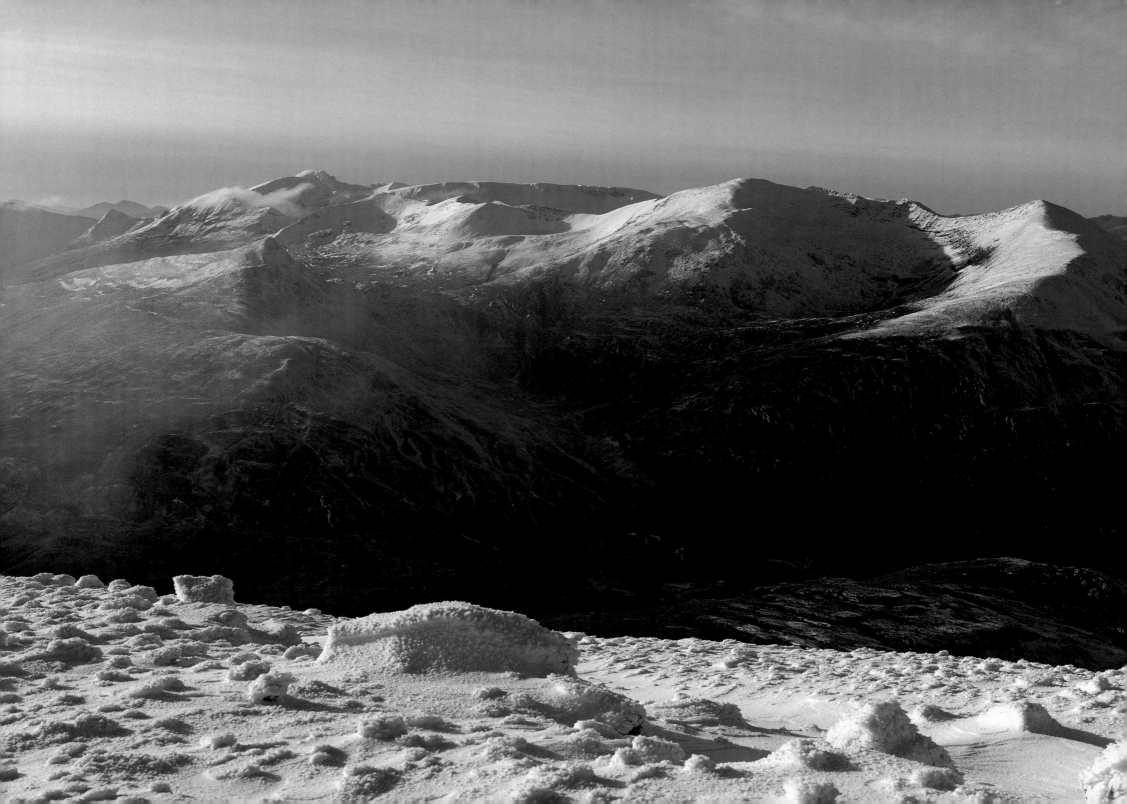

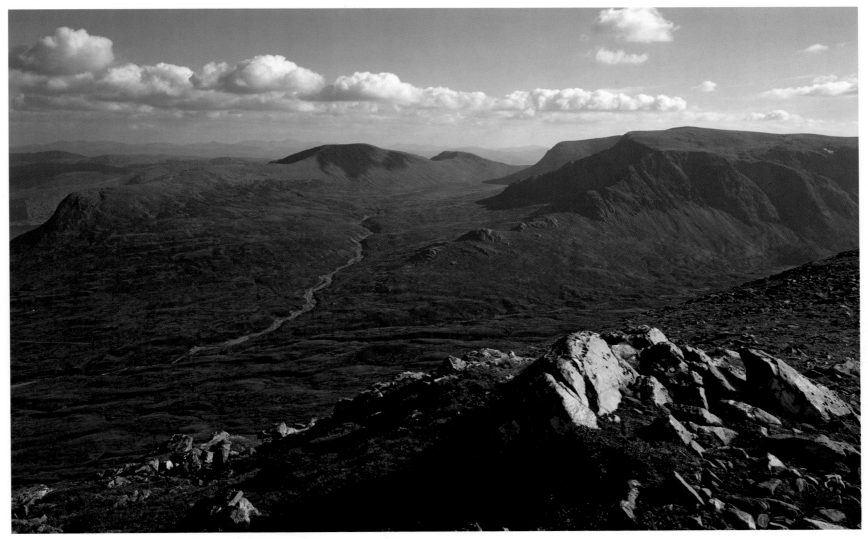

Beinn Bheoil and Ben Alder, from Carn Dearg.

Ben Nevis and the Grey Corries, from Stob Coire Easain *(opposite)*.

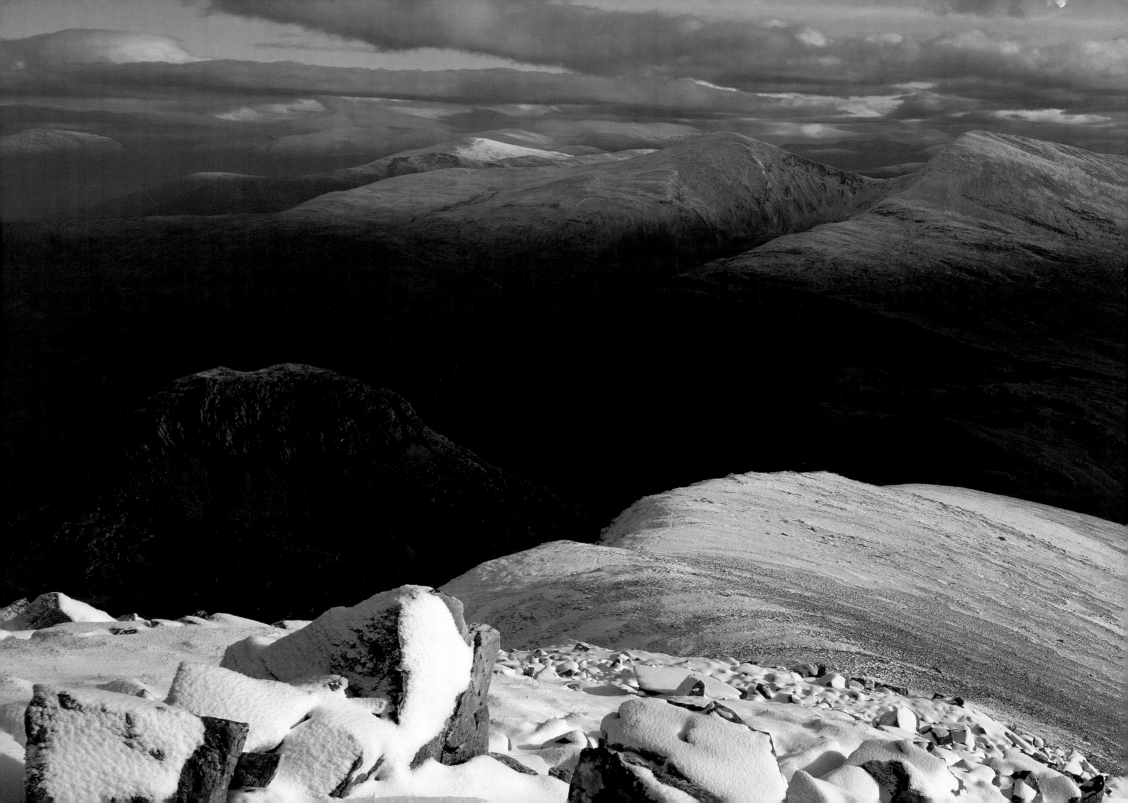

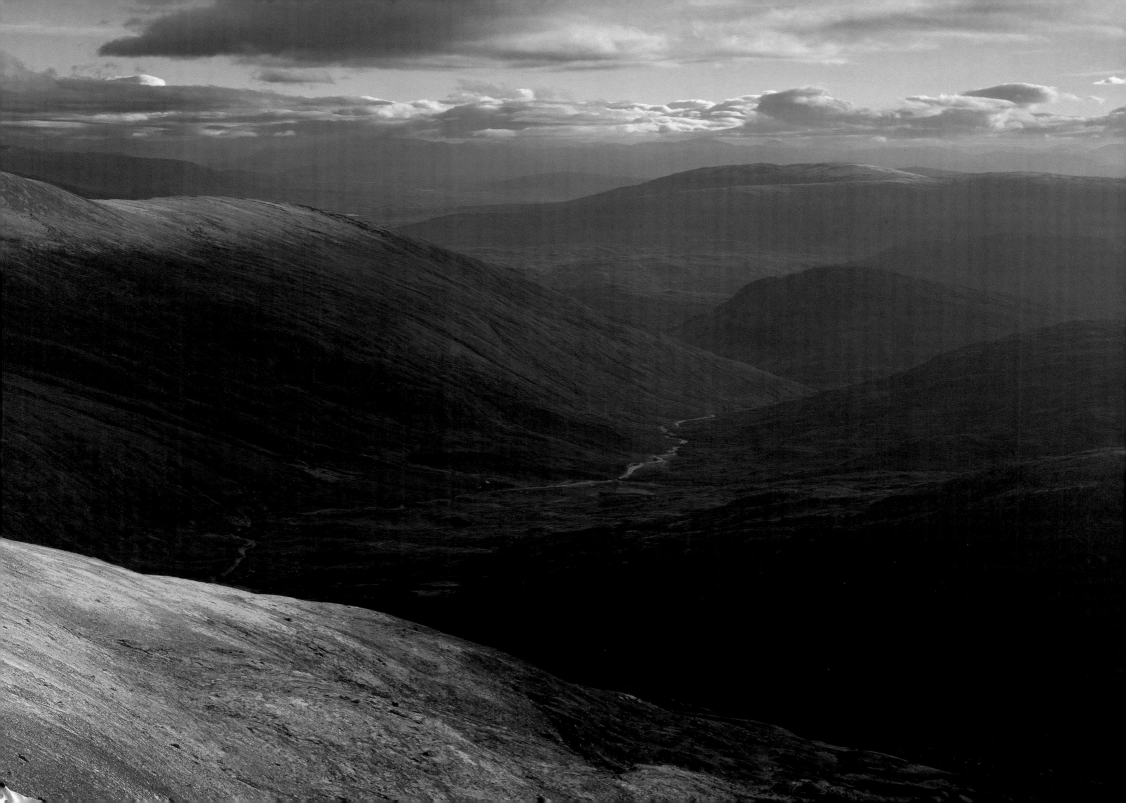

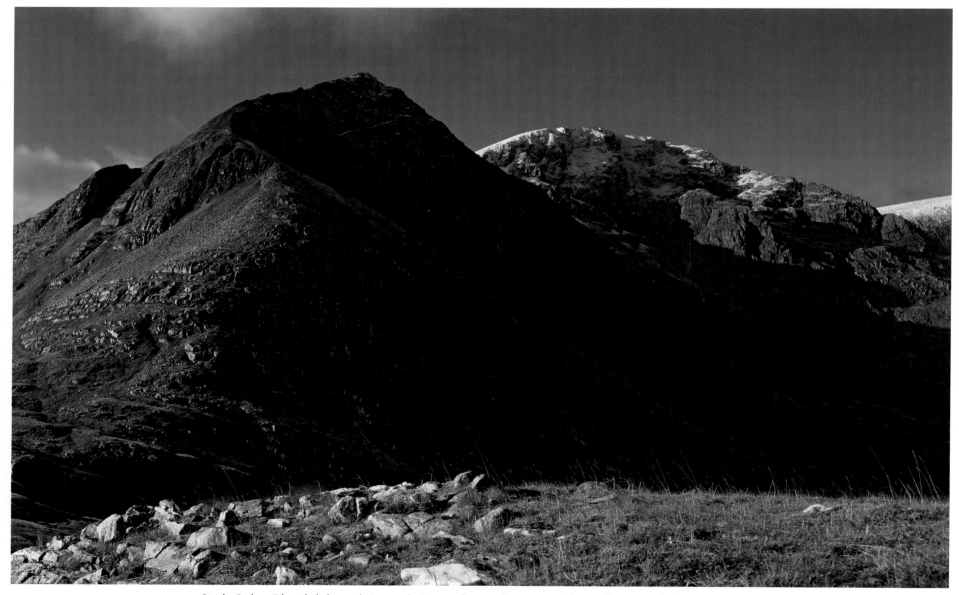

Stob Coire Bhealaich and Aonach Beag, from the west ridge of Sgurr Choinnich Beag.

Stob a' Choire Mheadhoin and Stob Coire Easain, from Stob Coire na Ceannain in the Grey Corries *(pages 52-3)*.

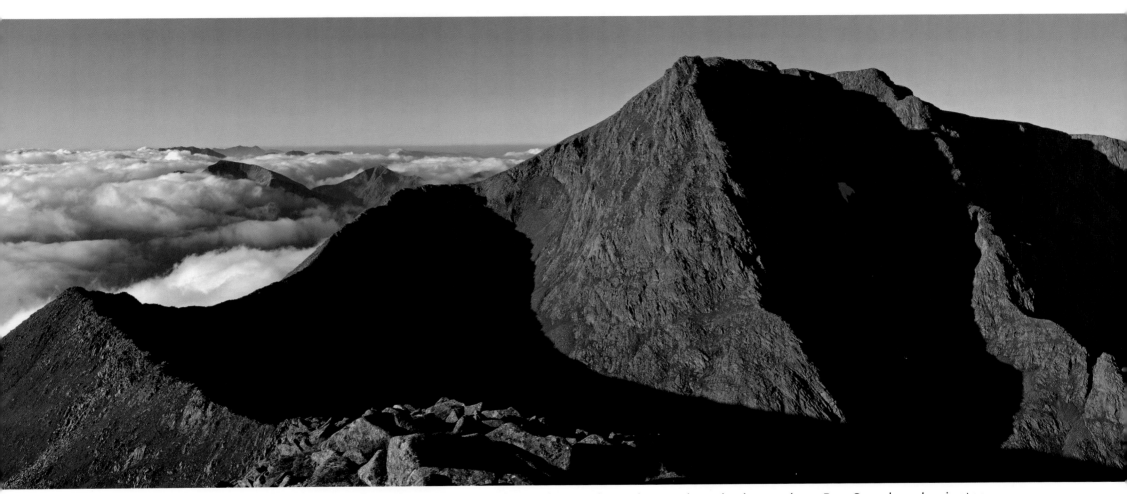

Ben Nevis from Carn Mor Dearg. The inversion stretches from Glen Nevis to the southern horizon, where Ben Cruachan dominates.

Binnein Mor and the Ring of Steall from Ben Nevis, with the Glencoe and southern hills beyond *(pages 56-7)*.

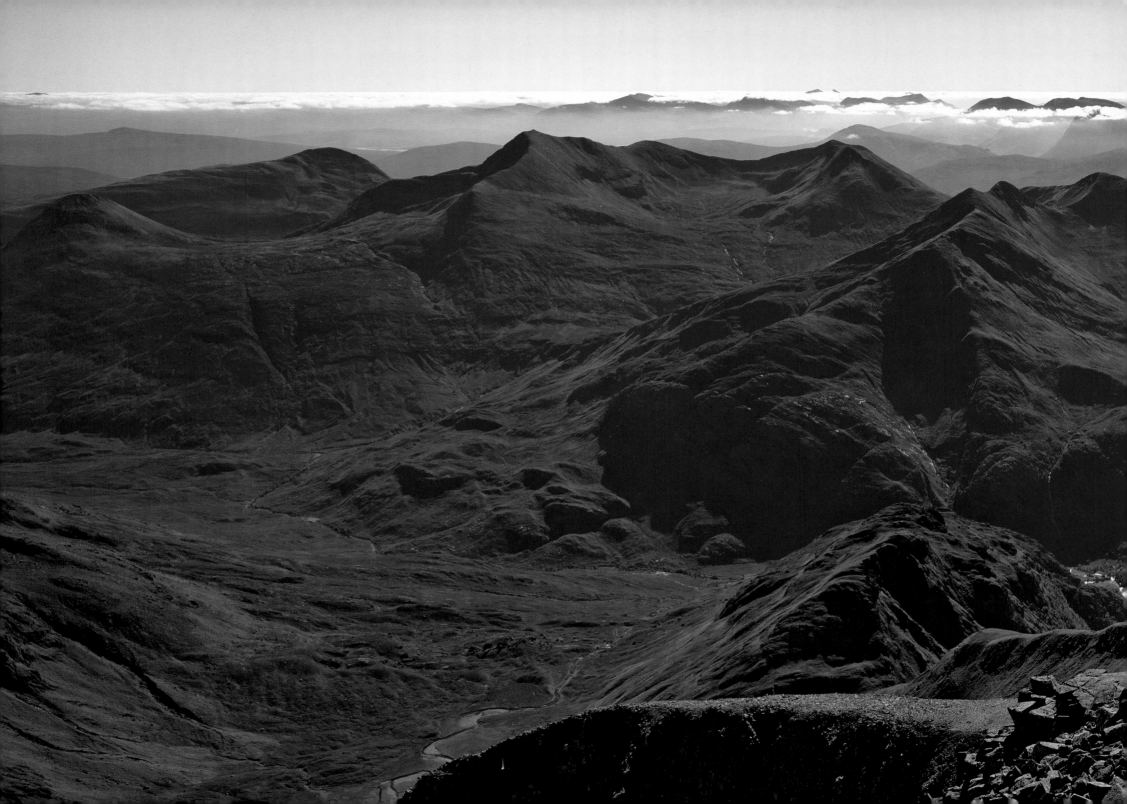

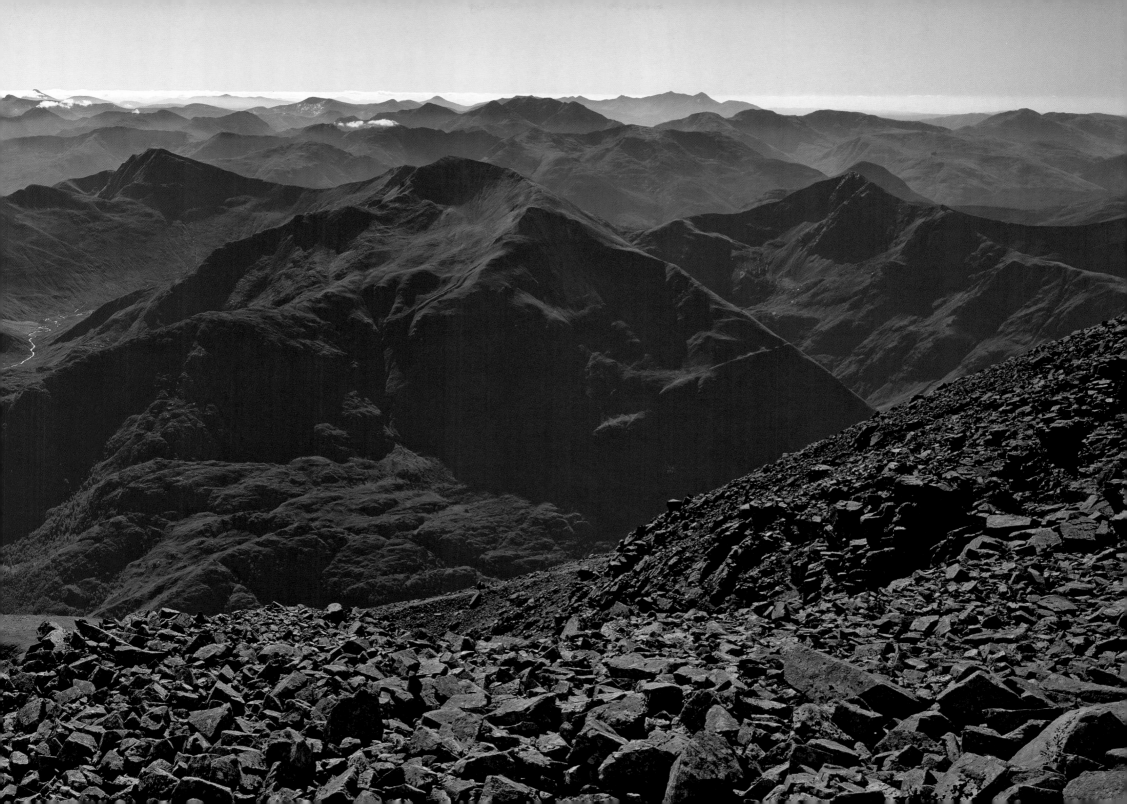

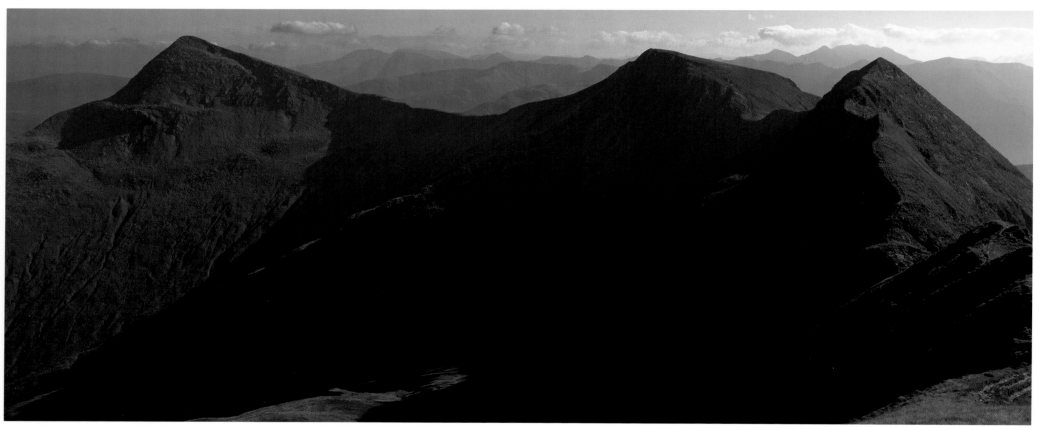

The Mamores – Am Bodach and the Devil's Ridge, from Sgurr a' Mhaim.

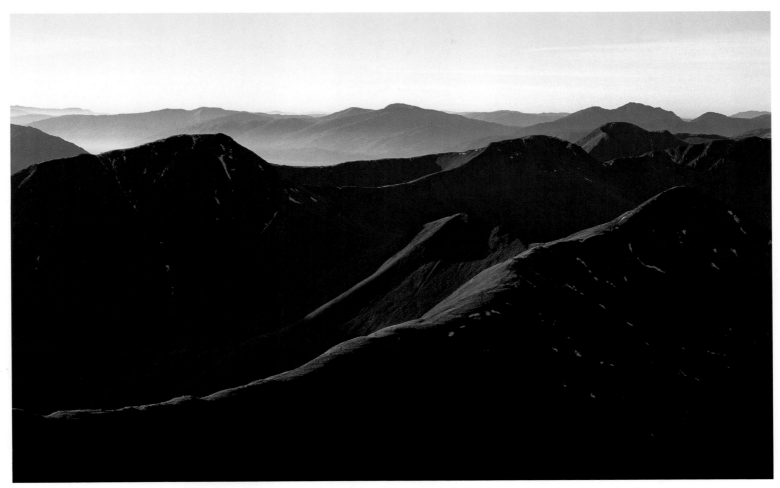

The western Mamores from Binnein Mor, with Garbh Bheinn and the Ardgour hills beyond.

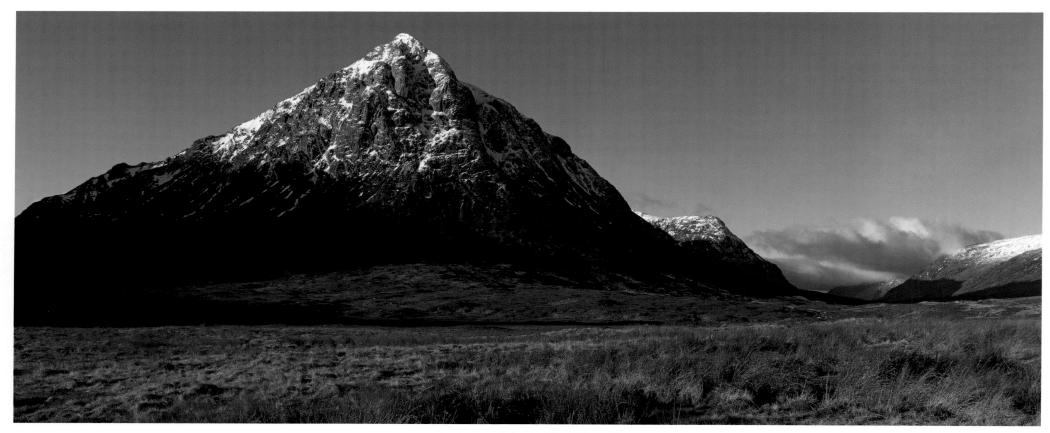

Stob Dearg, Buachaille Etive Mor.

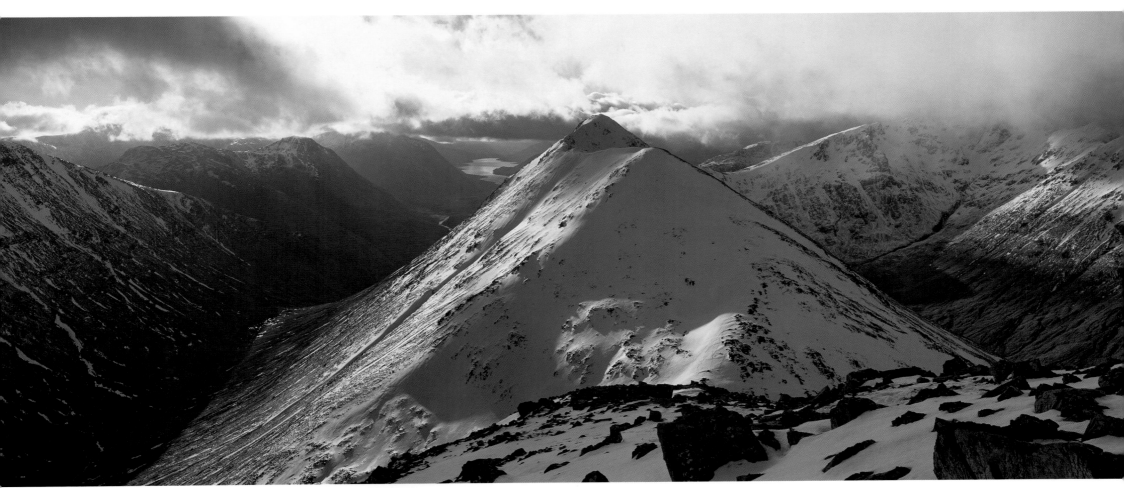

Buachaille Etive Beag – Stob Dubh from Stob Coire Raineach.

Glencoe from Sgorr nam Fiannaidh, Aonach Eagach *(pages 62-3)*.

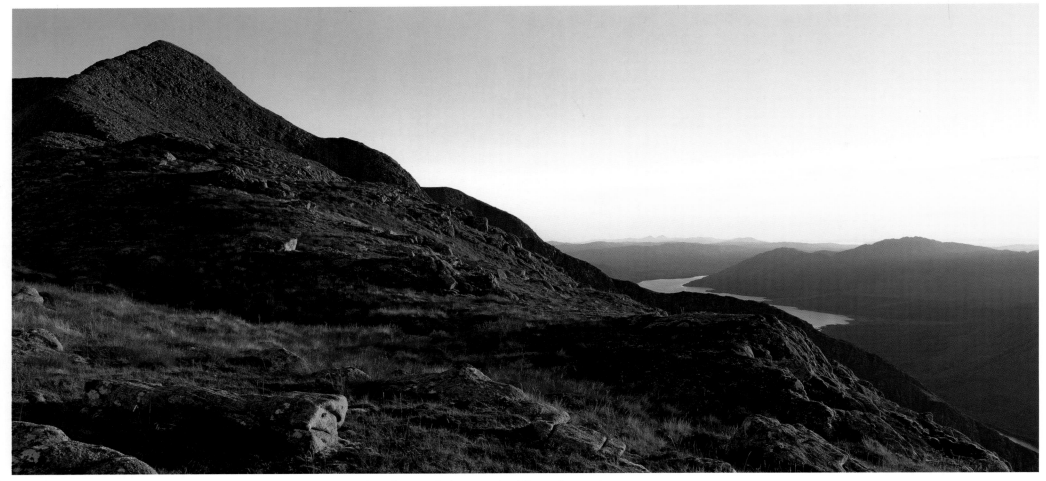

Loch Etive and the north ridge of Ben Starav at sunset.

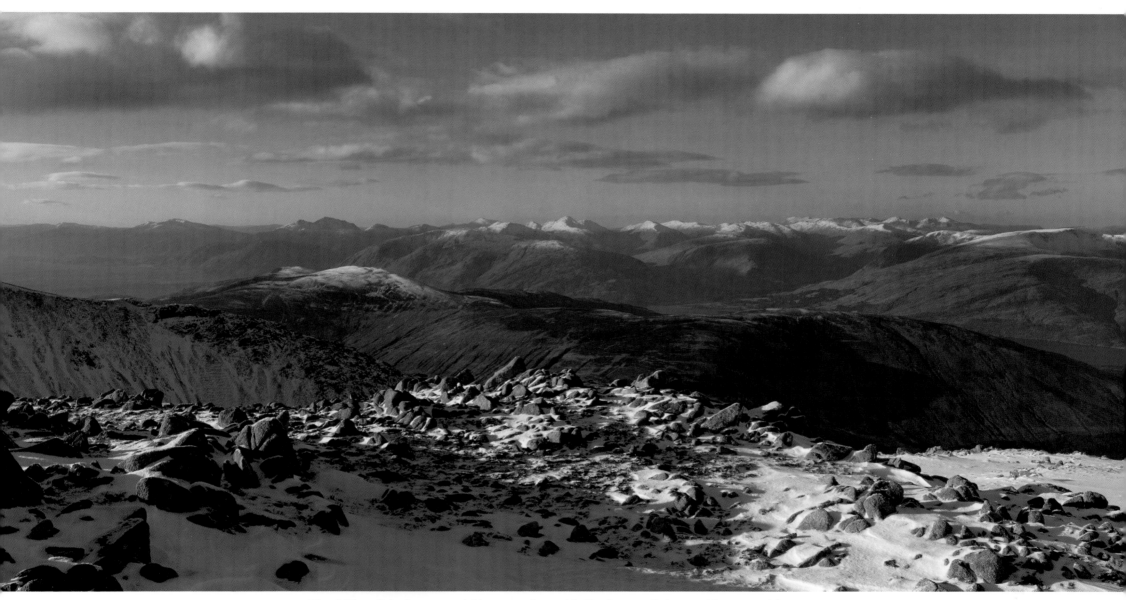

The hills of Ardgour and Morvern from Mullach nan Coirean, Mamore ridge.

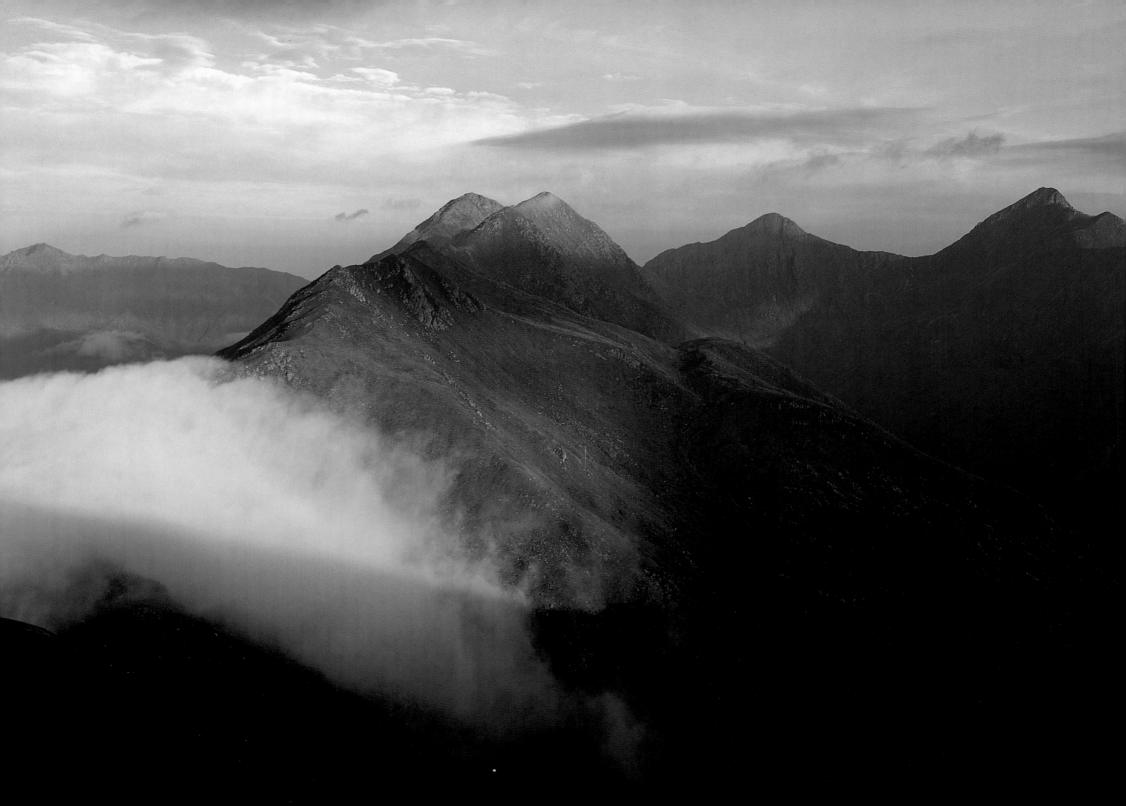

The Sunset Lands of The West

Glen Albyn, the Great Glen, slicing through the Highlands from Loch Linnhe to the Moray Firth, is the most notable feature when Scotland is viewed from space. Hillgoers too have it scored across their minds and don't our hearts beat faster at the thought of heading 'beyond the Great Glen', westwards, 'West, where all dreams lie'?

Ladhar Bheinn in the Rough Bounds of Knoydart is the most westerly Munro on the mainland and Ardnamurchan Point the most westerly place of mainland Britain. The very name 'Rough Bounds' is a lure, and to some extent, could be applied to the whole area. Height is not all and some of the grandest hills lie in Ardgour, Moidart and Morven, none above the 3,000 feet level.

The names resonate: Loch Sunart, Loch Ailort, Loch Nevis, Loch Hourn, Loch Duich, Strathfarrar, Glen Cannich, Glen Affric, Glen Shiel, Glen Dessarry, Glen Finnan, Loch Shiel, Loch Quoich, Loch Mullardoch, Loch Monar. The landscape is all east-west running glens, often continuing as narrow sea lochs, divided by long ridges of great character, rugged, but generally offering long traverses for the adventurous. The more inland ridges overlook lochs, and the seaward hills (especially on the peninsulas) are the real sunset hills of the West. Almost a quarter of Scotland's Munros lie in this area. The Landranger Sheet 25, apart from the north-west corner, is almost without surfaced roads shown, the largest area like that in Britain. Access to the hills is a challenge in itself.

Strangely, the area is topped and tailed by railways: the Fort William–Mallaig line and the Inverness–Kyle line, the most scenic lines in Britain.

Roads parallel their tortuous routes and by Loch Garry and Glen Shiel there's a 'Road to the Isles' but other roads that run up the glens end at their heads, or in one case, drops dizzily to the sea at Kinloch Hourn. Access by sea is often a necessity as well as a treat, and many a hill I've reached has been aided by using canoe or push bike (much pushing usually!). Ascents will often be from sea level and there is much bare rock to make this a physically demanding area.

Strangely, this so mountainly landscape is only the worn down, eroded, remnant of a mighty range eons ago. The watershed lies tight against the western seaboard, the east-flowing waters have a long journey ahead, often becoming lochs, many dammed for hydro power.

Above Glen Affric, Carn Eighe and Man Sodhail are 12 and 14 in order of Munro height, but though there are individual hills of character like Garbh Bheinn of Ardgour, Resipol, Ladhar Bheinn (the jewel in the John Muir Trust crown), the Saddle with its Forcan Ridge, Sgurr Fhuaran (the longest continuous steep slope in Scotland), it is mainly the long ridges with gathered Munros that is the unique appeal. Even Bonnie Prince Charlie climbed one Munro, Sgurr Thuilm, in his hide and seek wanderings following Culloden, and Sir Hugh Munro placed Beinn Sgritheall (Sgriol) as a favourite for its sunset view to the west.

When man first arrived in these parts it was by the highway of the seas and the byways of the lochs, much of Scotland then being mountain, forest and bog, so perhaps this pioneering zest still works in us today. Take the sea route from Mallaig to Inverie to test the West.

Kintail – sunrise on the Five Sisters, from Saileag.

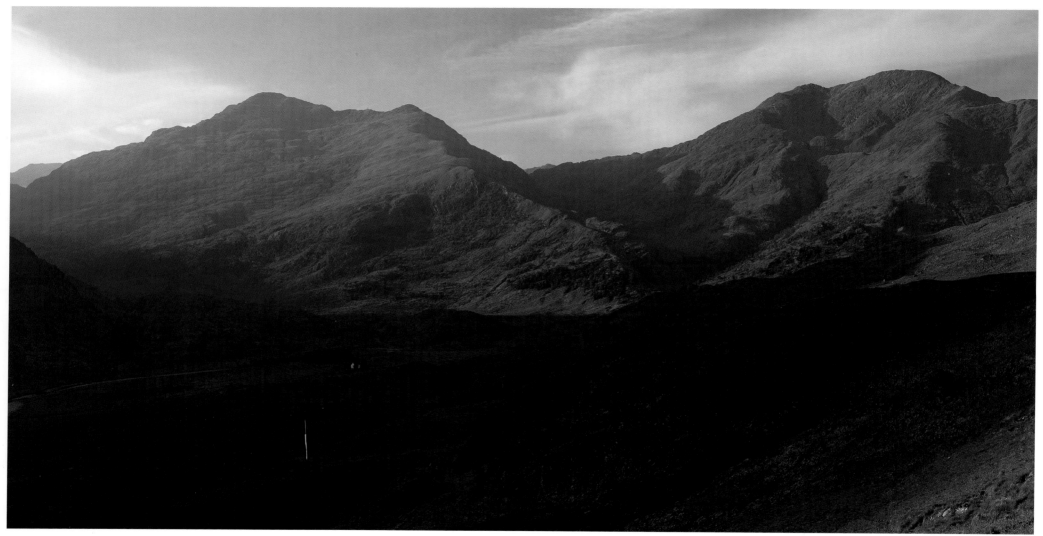

Glen Barrisdale, Knoydart, with Sgurr a' Choire-bheithe and Luinne Bheinn.

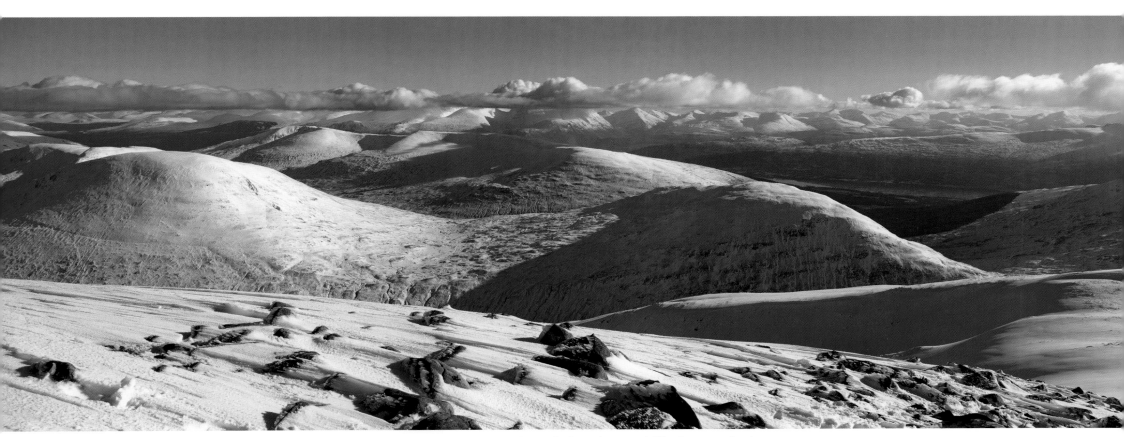

The Grey Corries, Ben Nevis and the Glencoe hills from Gulvain.

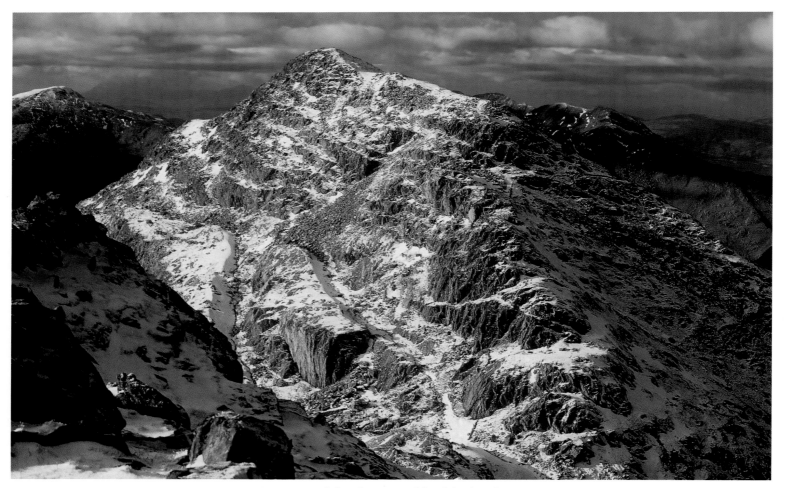

Sgurr na Ciche from Garbh Chioch Mhor.

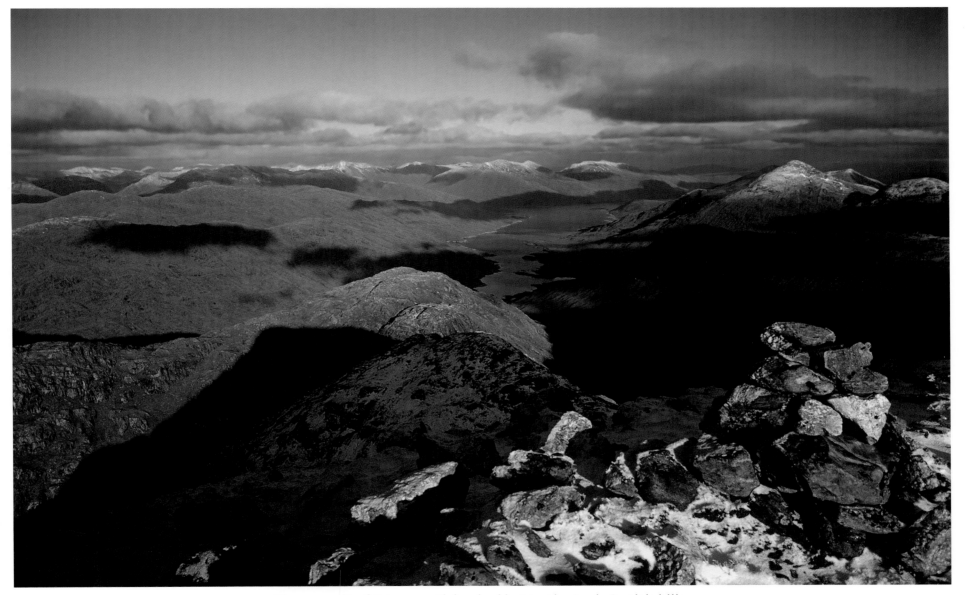

The summit of Sgurr na Ciche, looking to the Loch Quoich hills.

Gleouraich, Gairich and Loch Quoich from Sgurr a' Mhaoraich *(pages 72-3)*.

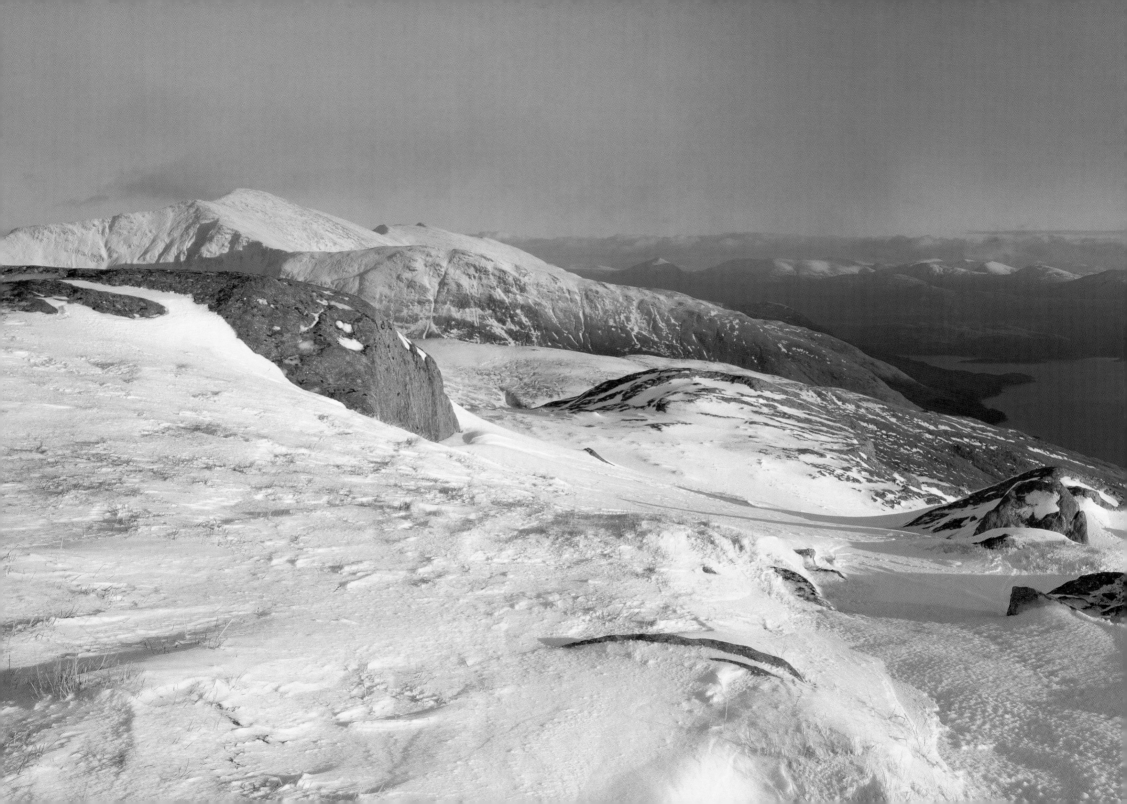

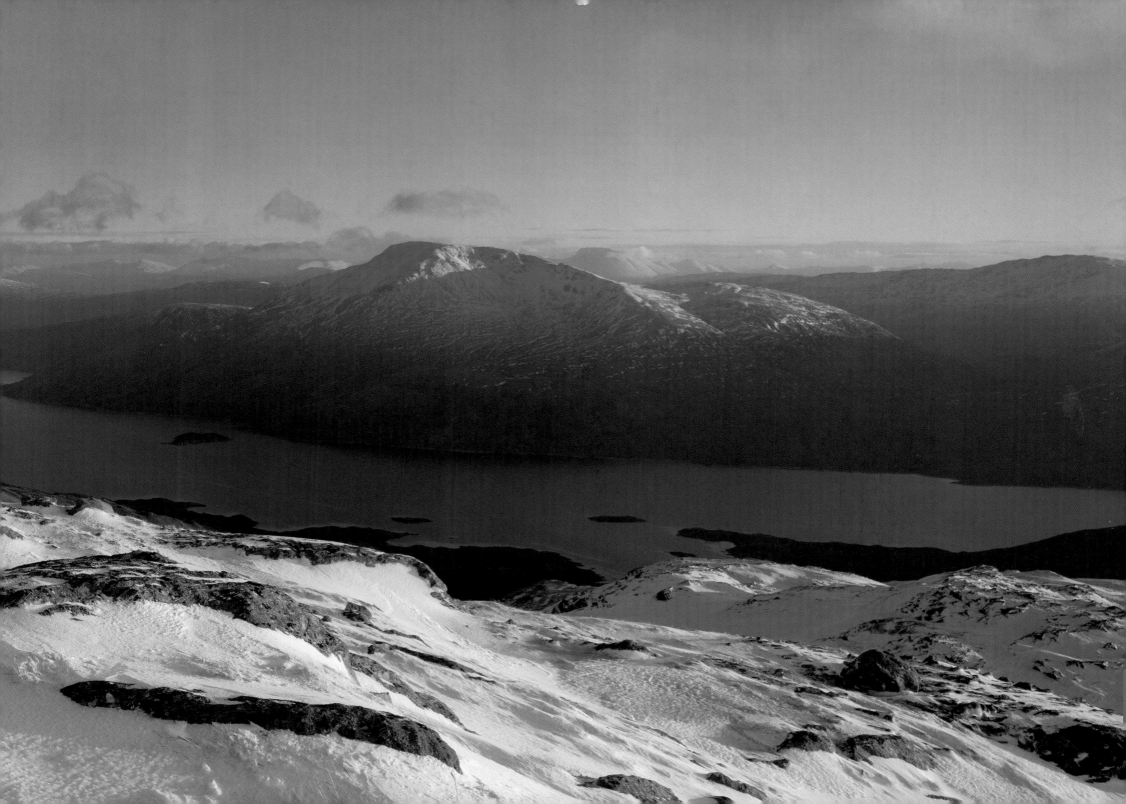

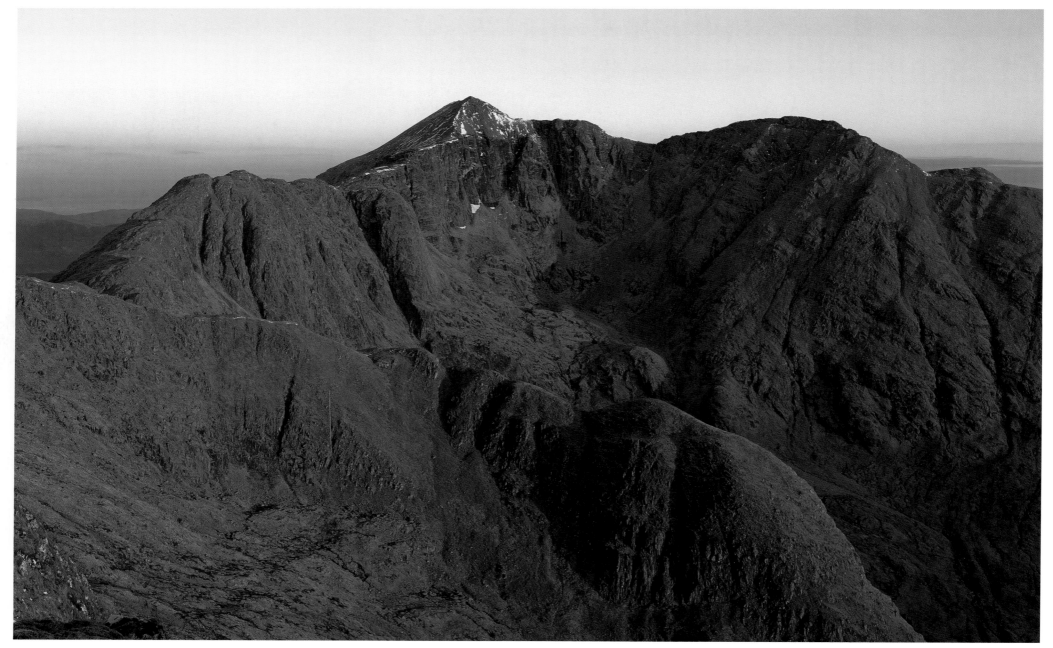

Sunrise on Ladhar Bheinn, Knoydart.

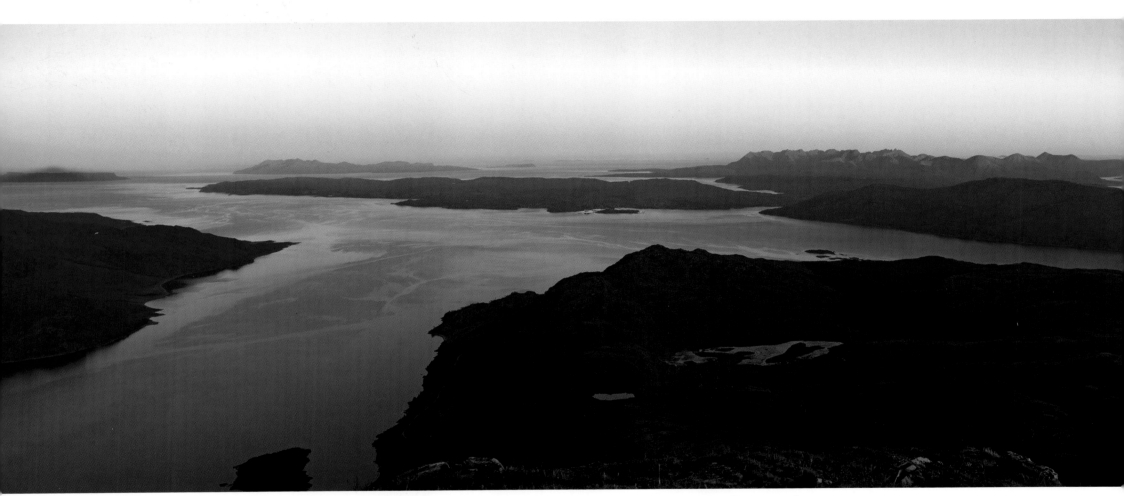

Eigg, Rum and the Skye Cuillin from the summit of Beinn Sgritheall, at sunrise.

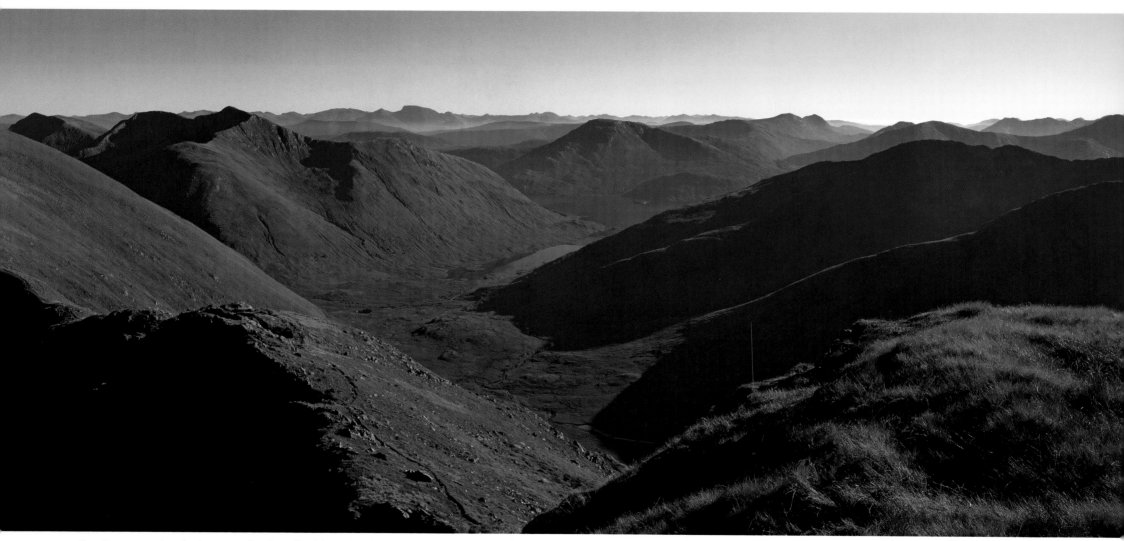

On Sgurr an Lochain, south Kintail ridge, looking to Gleouraich and the Loch Quoich hills with Ben Nevis and the Glencoe mountains in the distance.

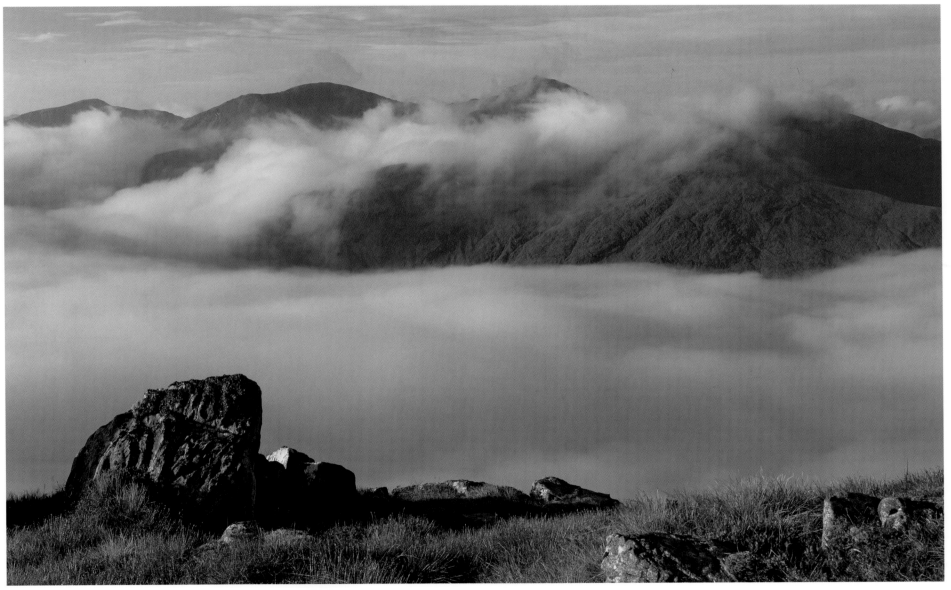

Looking across Glen Shiel to Sgurr an Doire Leathain and Sgurr an Lochain, from Sgurr nan Spainteach on the Five Sisters ridge.

The mountains of Kintail, from the summit of a' Chralaig *(pages 78-9)*.

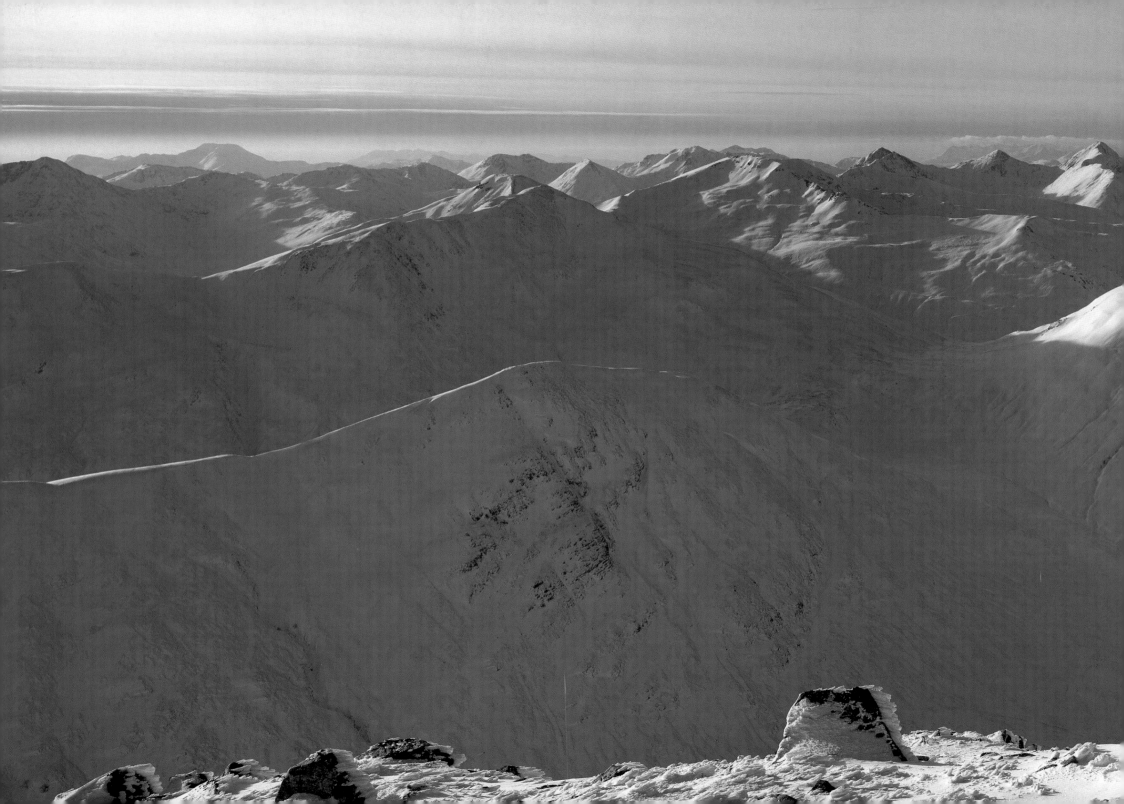

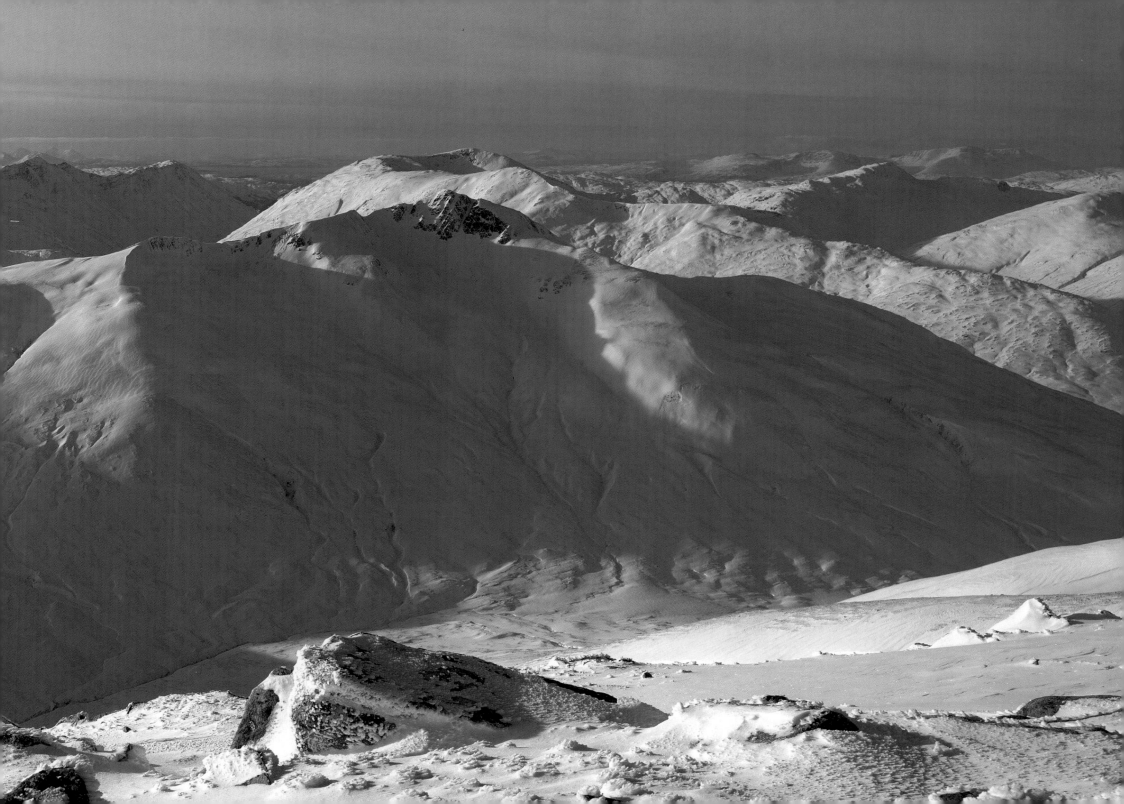

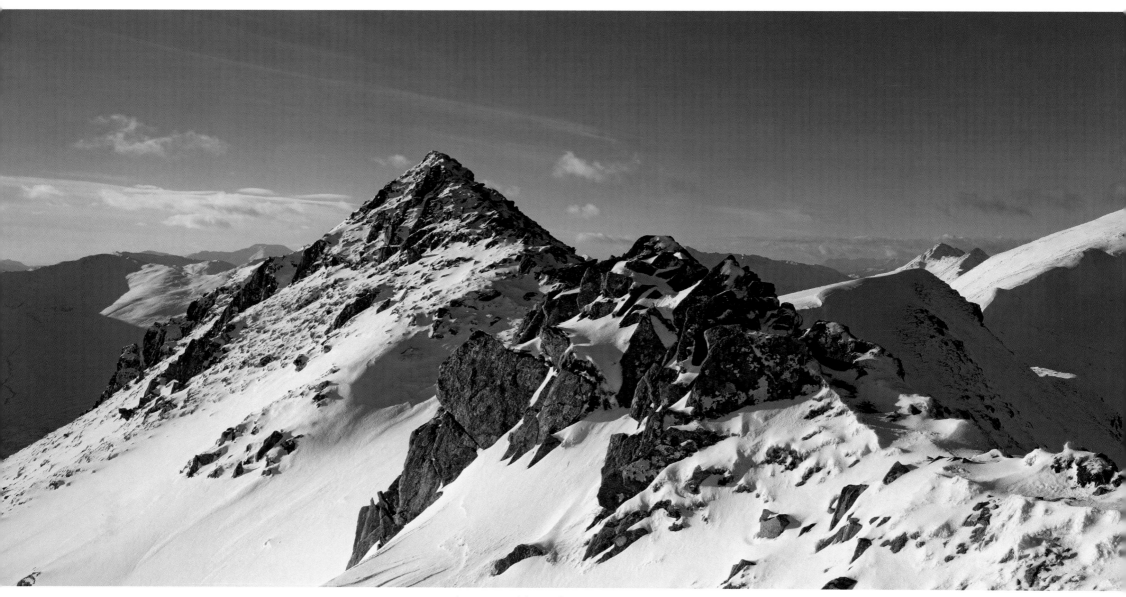

The west ridge of Aonach Meadhoin.

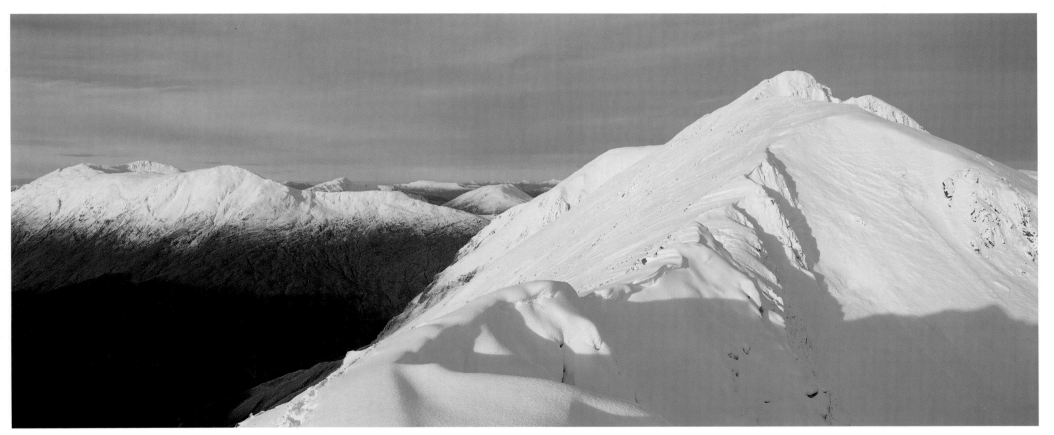

The summit of Ciste Dhubh from the south ridge, with Beinn Fhada on the left.

Winter sunset on the Five Sisters of Kintail *(pages 82-3)*.

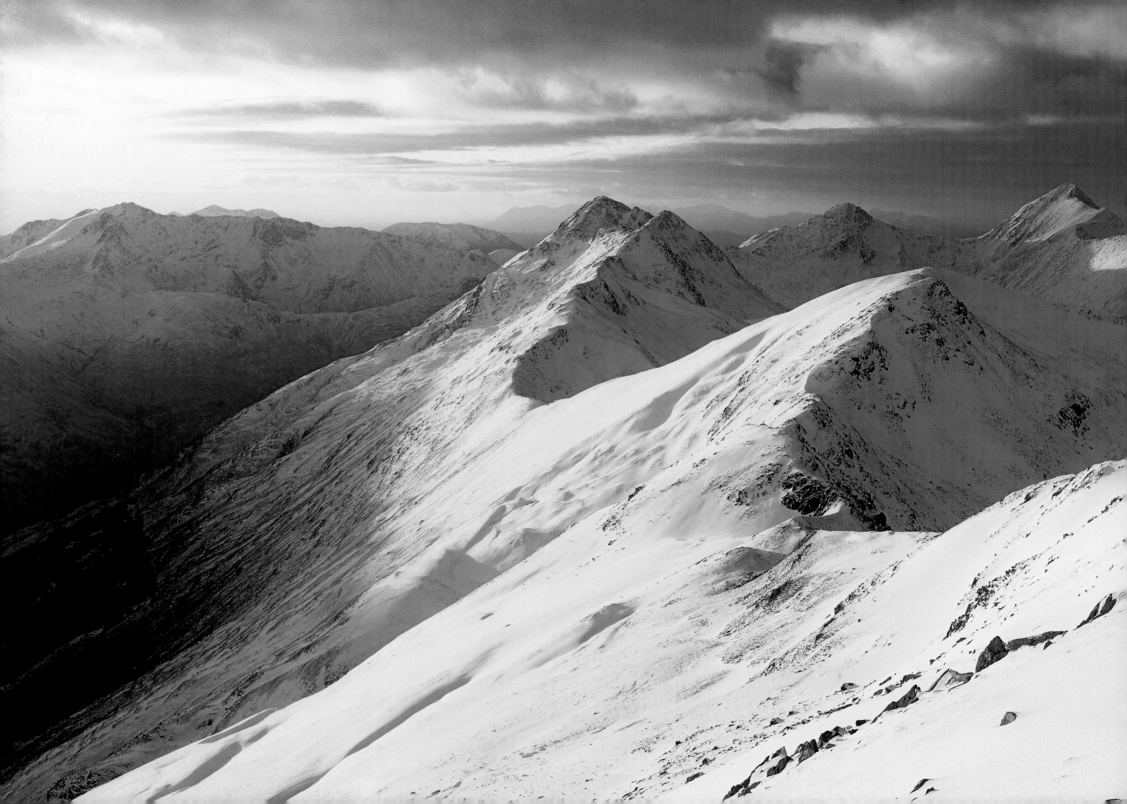

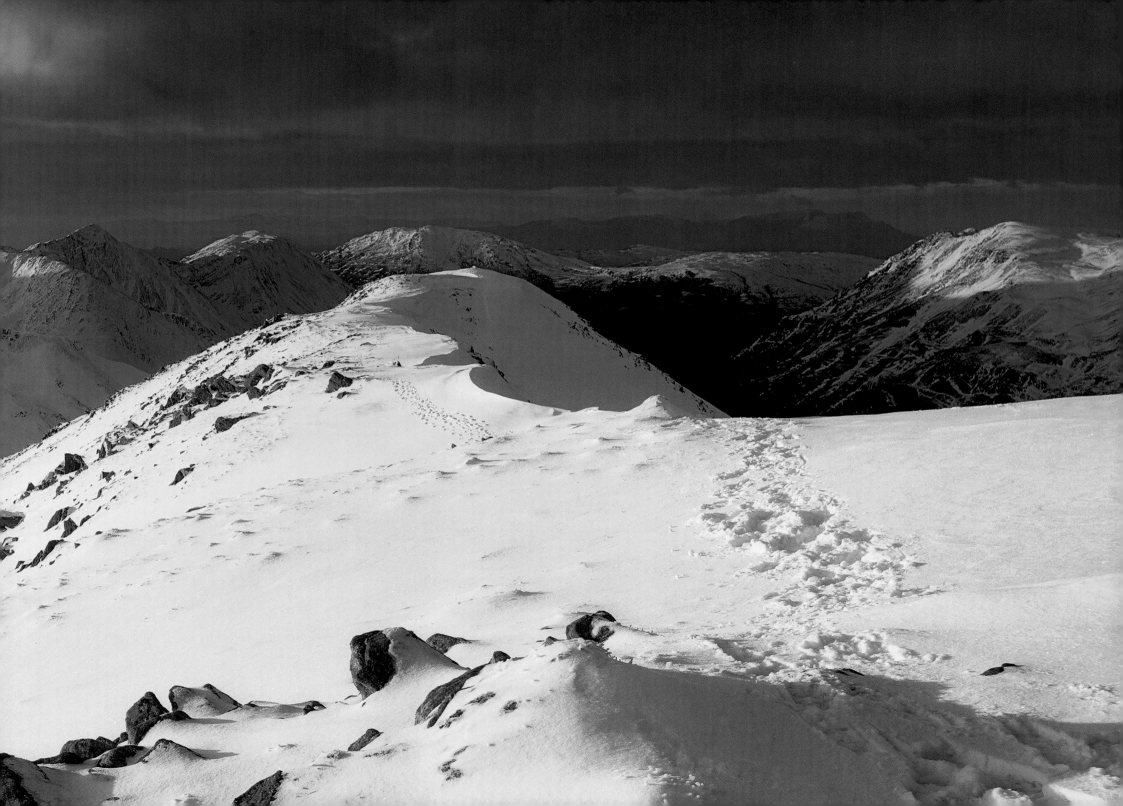

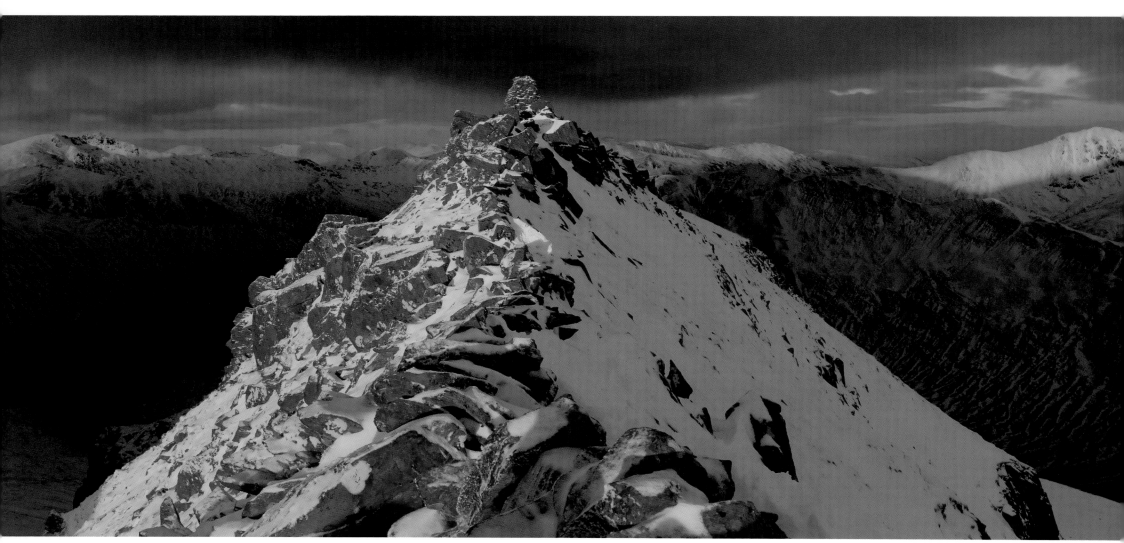

Summit cairn, Sgurr a' Bhealaich Dheirg.

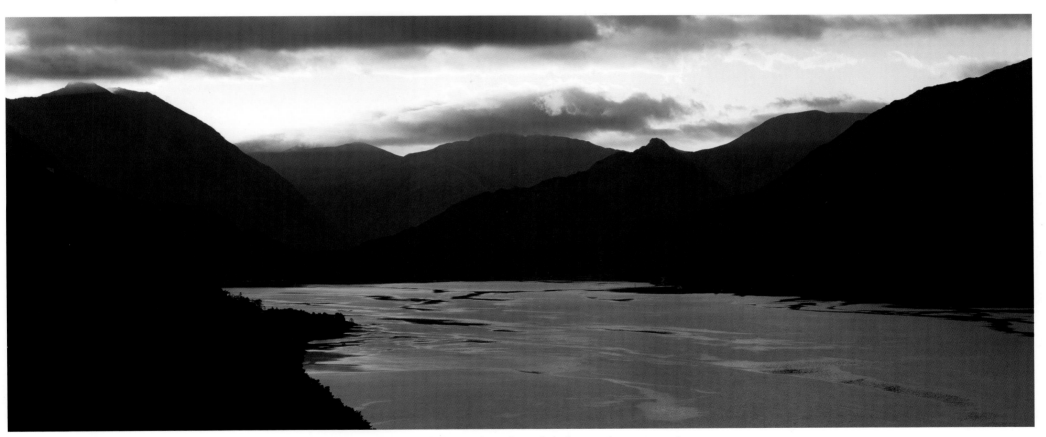

The Glen Shiel hills and Loch Duich from above Inverinate.

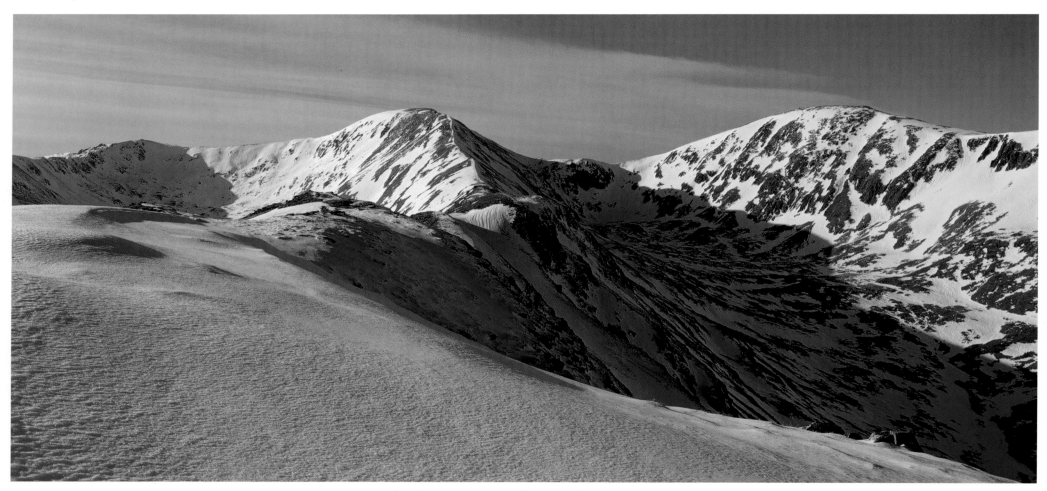

Mam Sodhail and Carn Eige from Mullach Cadha Rainich.

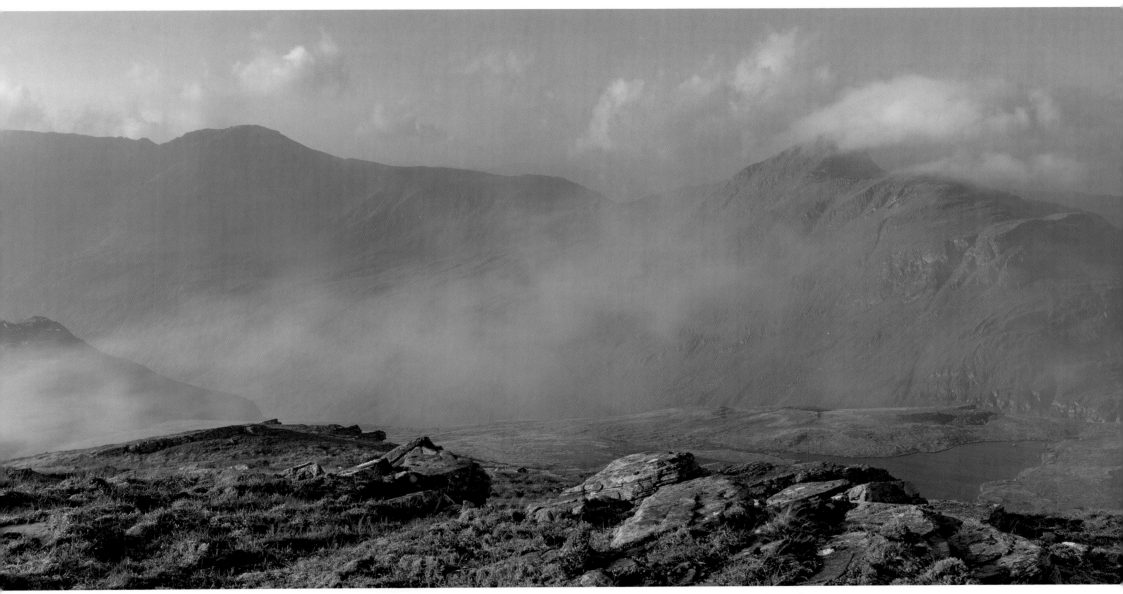

Dawn cloud on Lurg Mhor and Bidein a' Choire Sheasgaich, from Beinn Tharsuinn.

The Strathcarron and Torridon hills of the northern Highlands, from Sgurr na Feartaig *(pages 88-9)*.

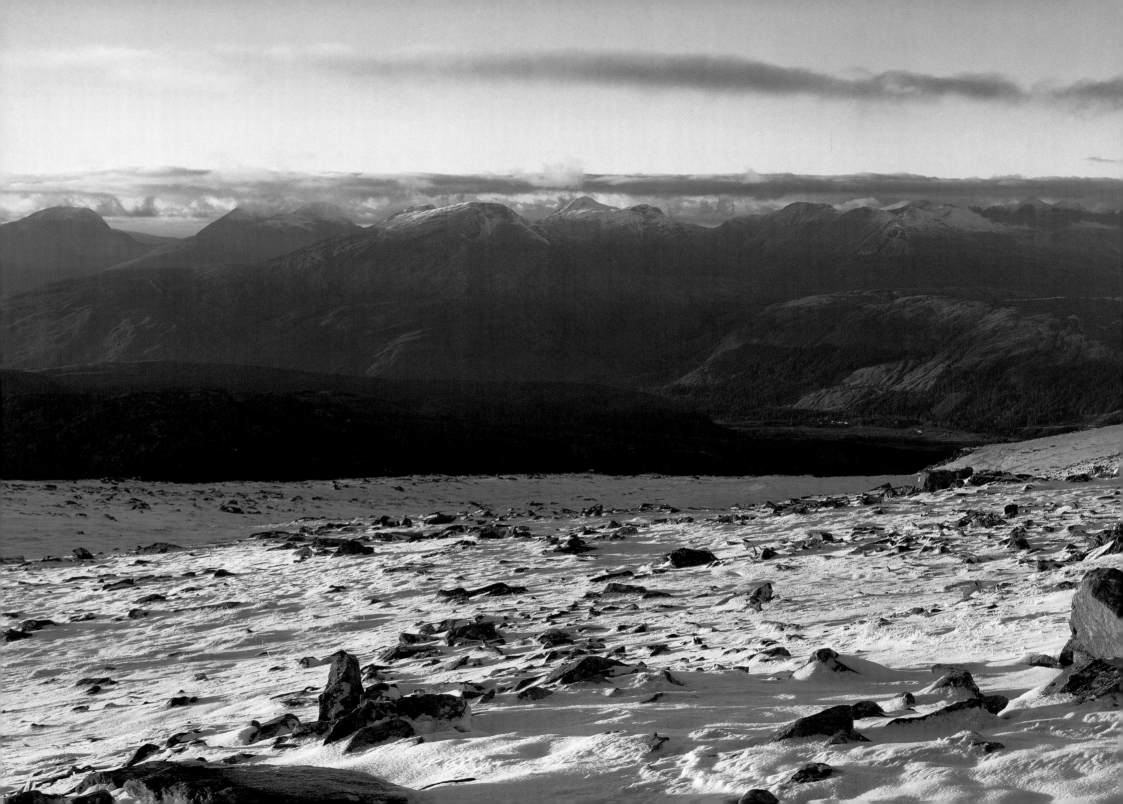

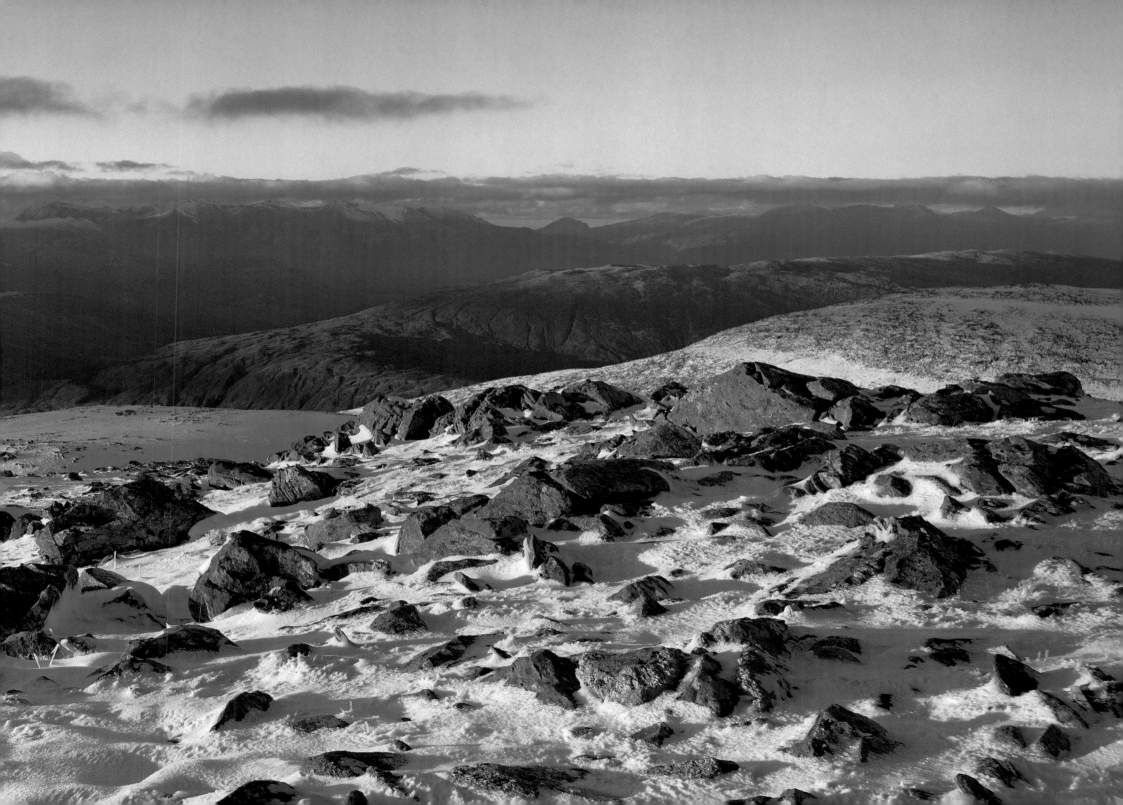

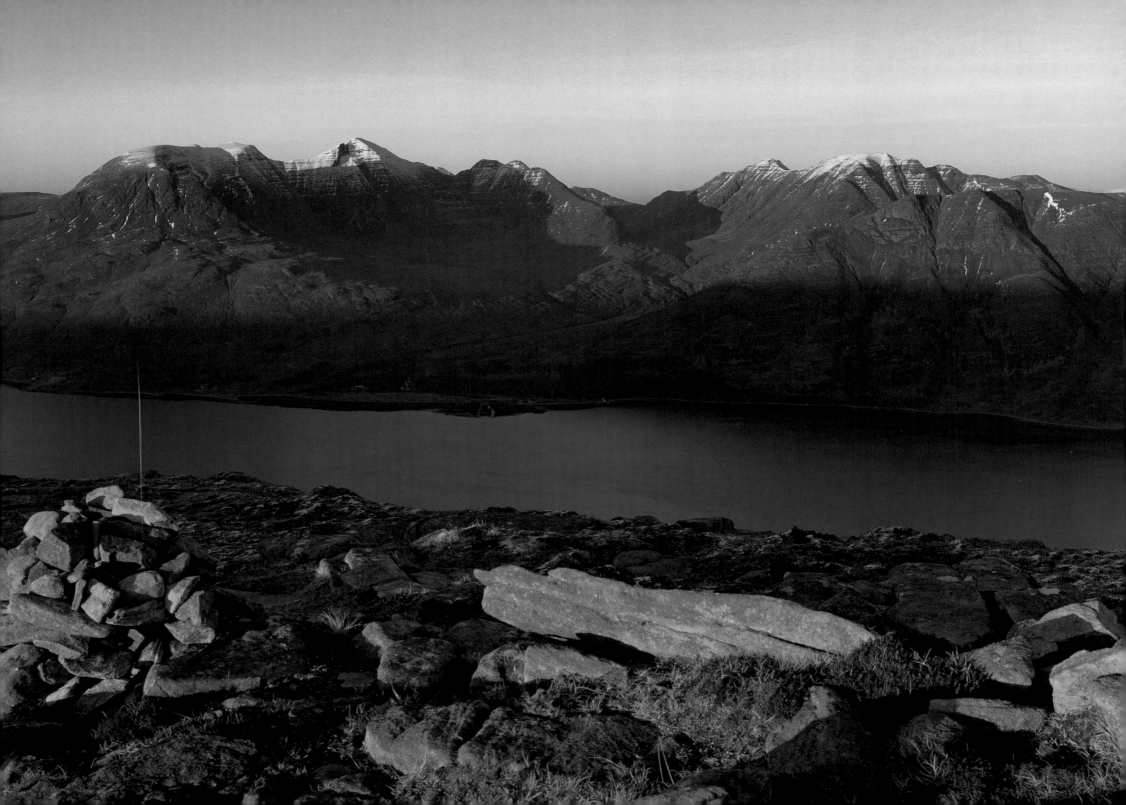

The Sparse Northlands

The northern Highlands are neatly bounded by man's utilisation of nature: the Kyle railway line and its attendant roads. Rail and road also wend up the east to Wick and Thurso, a very different world, as Morven apart, the underlying flagstones create a lowland landscape. Much of the north west is also low lying and peaks often rise in startling grandeur as a result – like couchant Suilven or kittenish Stac Pollaidh.

Years ago I asked readers of a magazine to list their top twenty Scottish hills. Two came out above all others: An Teallach and Liathach and both are in this area and both give magnificent traverses over high, craggy crests. Here we are aware of cataclysmic geological history as nowhere else in Scotland. Years ago in Glen Torridon a wag touched up warning signs for sheep so they became mammoths. Once could almost believe it, and haven't the hills themselves been called pachydermatous?

The Torridonian sandstones and Lewisian gneisses of the western seaboard have been overridden by the rocks of the west of our area, in the Moine Thrust which runs from Whiten Head to Loch Alsh. Hard to conceive the scale of such movements. Early geologists simply couldn't. All this area has also slid miles along the line of the Great Glen. The 'giants' of Torridon like Liathach are the remnants of alluvial deposits, kilometres deep, too old for fossils, and standing on Lewisian gneiss, the bedrock of the coastal strips and the Outer Hebrides (hence the name) and among the world's oldest rocks. In Assynt and Ben Stack the gneiss attains hill status. Many of these sturdy hills are capped with quartzite. Lord Cockburn, travelling in the eighteenth century, noted in his diary,

'Except for snow I never saw a whitsh hill before.' He thought Sleugach (Slioch) and Quingan (Quinag) 'the grandest of hills'.

The Torridonian strata are mainly horizontal (with vertical jointing) so have weathered into the terraced cliffs and bastions so well displayed. Making the summits in the north requires judgement and route choosing skills seldom needed elsewhere. Hands as well as feet will be needed to reach some of the summits. The quartzite crests and screes of Fionaven and Arkle are a special feature, calling for good lungs and strong ankles. In the north we walk very aware of brutal geological revelations.

While the long east-west ridges no longer dominate, as further south, the variety of landscape is still pronounced and is often neatly packaged into characteristic blocks: Applecross, the Coulin Forest, Torridon, north of Loch Maree, An Teallach, the Fannichs, Easter Ross, Beinn Dearg, Coigach, Assynt, Sutherland's north west and Caithness's Morven. Individual hills stand prominent as nowhere else in Scotland. Some of these areas are huge and roadless, which makes them unbeatable trekking country. Of the score of coast-to-coast walks I've made across Scotland, the most memorable was Lochinver to Berriedale (Suilven to Morven). The only sadness was the absence of human habitation. The people have gone, voluntarily or otherwise, and only lonely rickles of stone in far corners stand as their memorials.

That people lived here from earliest times perhaps indicates a kindlier climate in the past, but still demonstrates the pioneering nature of man. We can only stand amazed in a place like the Camster Cairns in Caithness or before the many, still engmatic, brochs. We walk humbly in the northlands.

Beinn Alligin, Beinn Dearg and Upper Loch Torridon from Sgurr na Bana Mhoraire, Beinn Damh.

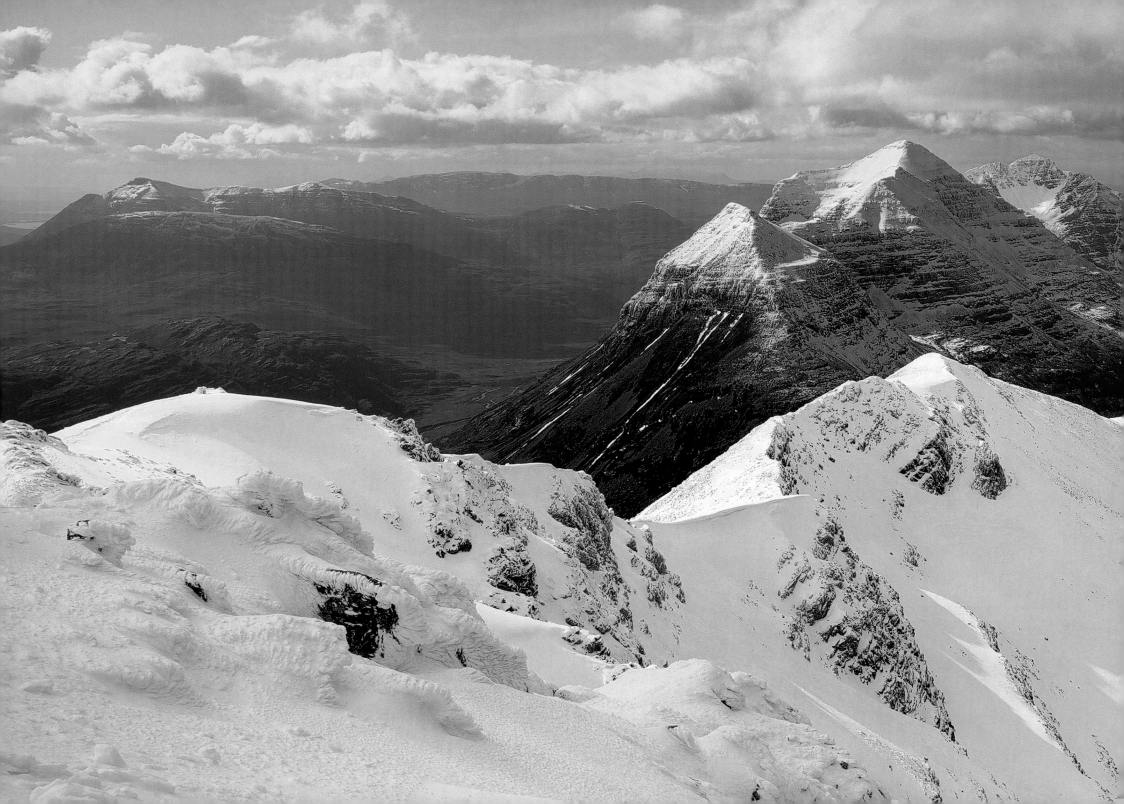

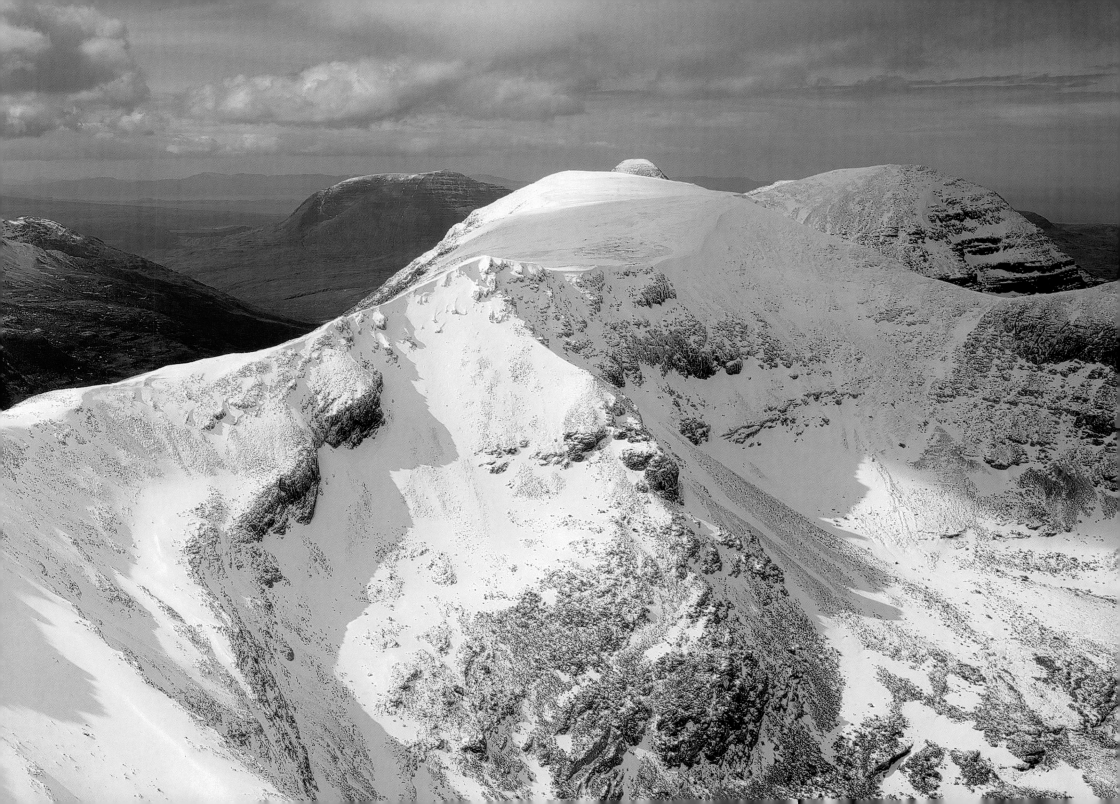

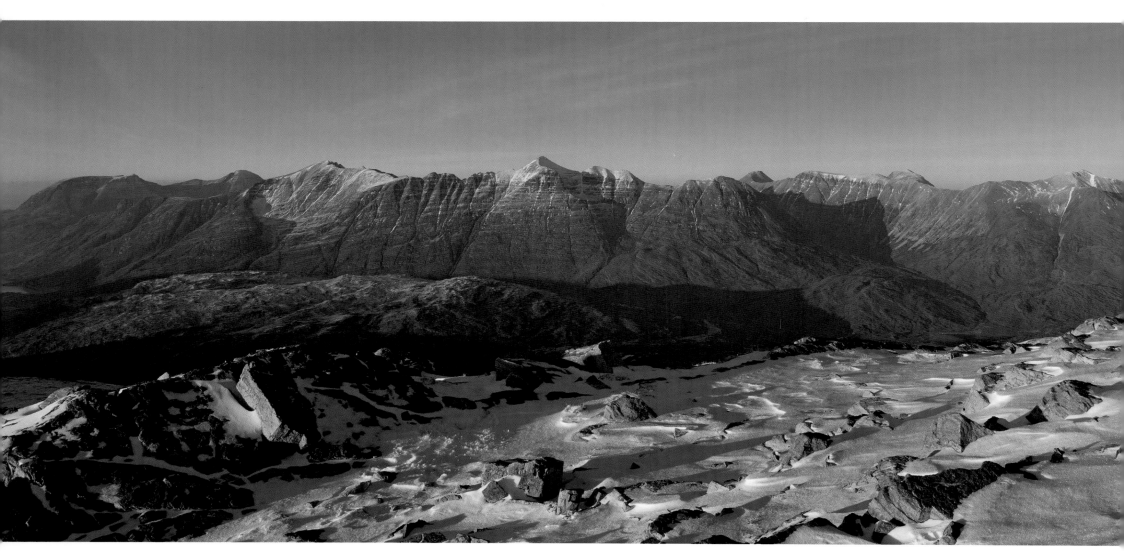

Torridon's big three – Beinn Alligin, Liathach and Beinn Eighe from Beinn Liath Mhor.

On Spidean Coire nan Clach, Beinn Eighe, looking along the ridge to Sail Mhor with Liathach in the background *(pages 92-3)*.

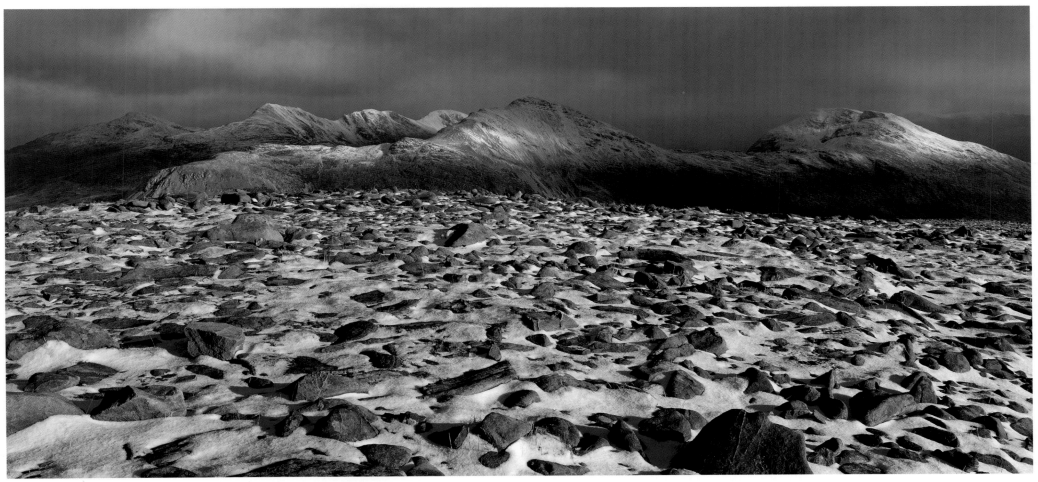

The Coire Lair hills of Beinn Liath Mhor, Sgorr Ruadh and Fuar Tholl from Maol Chean-dearg.

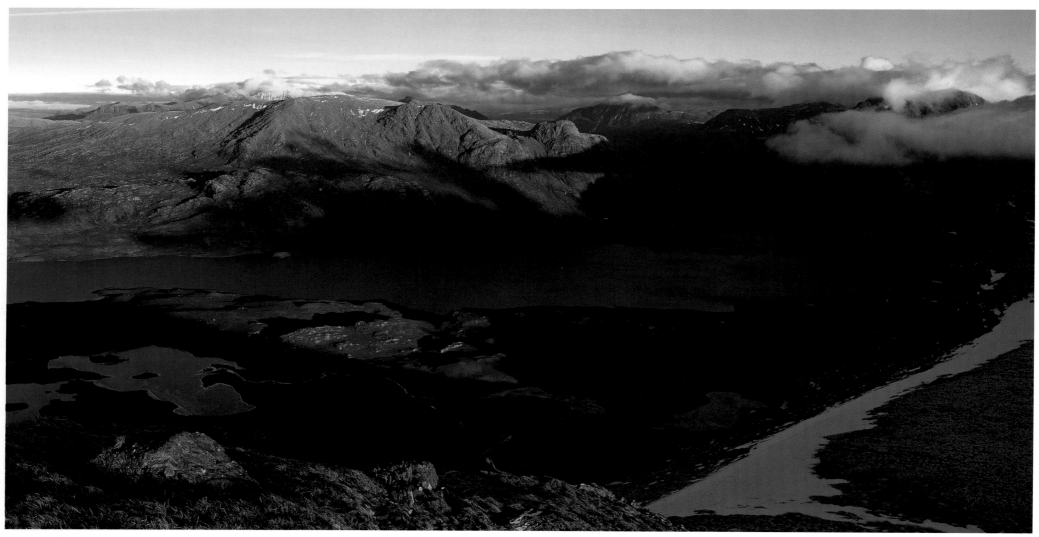

Looking into the Fisherfield wilderness. Fionn Loch, Dubh Loch, Beinn a' Chaisgein Mor, Ruadh Stac Mor and A' Mhaighdean from Beinn Airigh Charr.

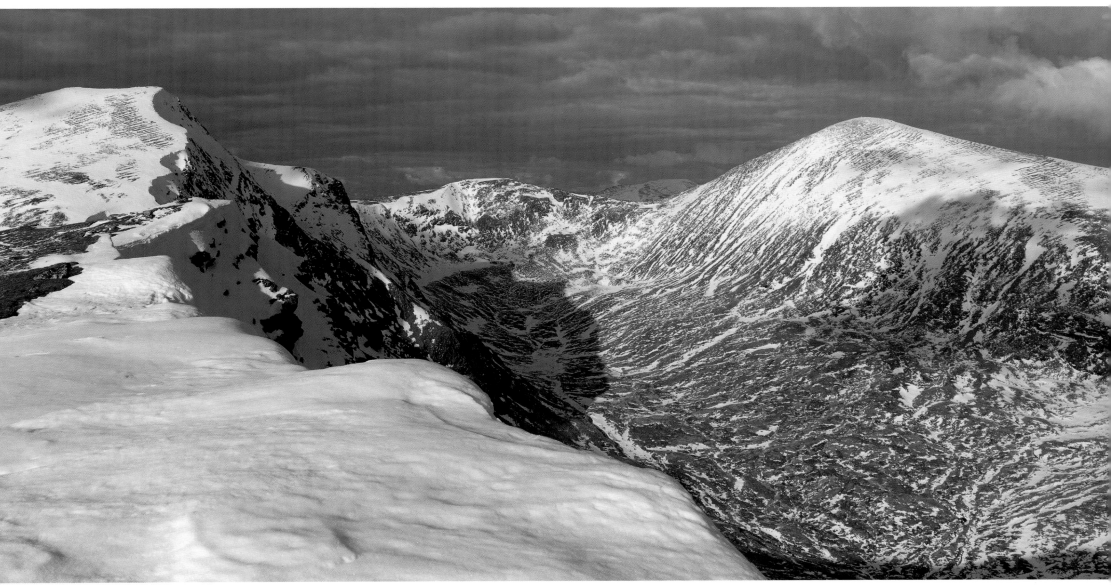

Sgurr nan Clach Geala and Sgurr Mor, the highest Munros on the Fannich ridge, from Sgurr nan Each.

Winter on An Teallach — the ridge from Sail Liath *(pages 98-9)*.

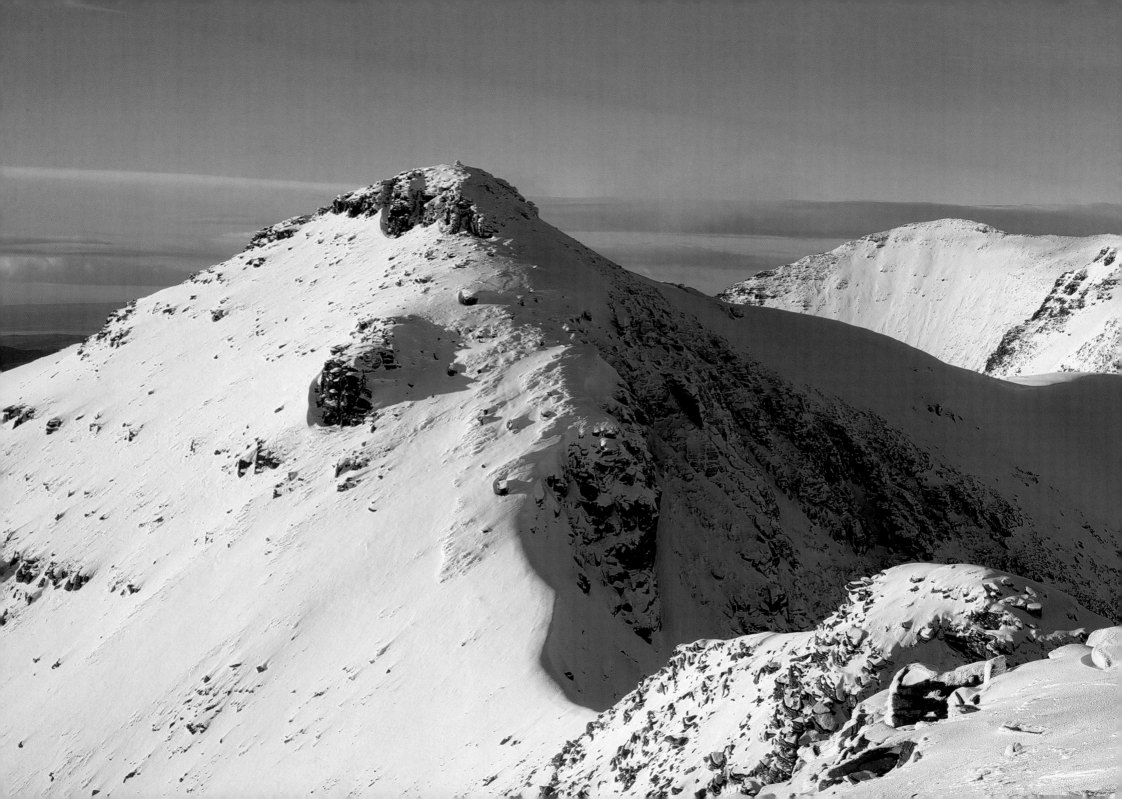

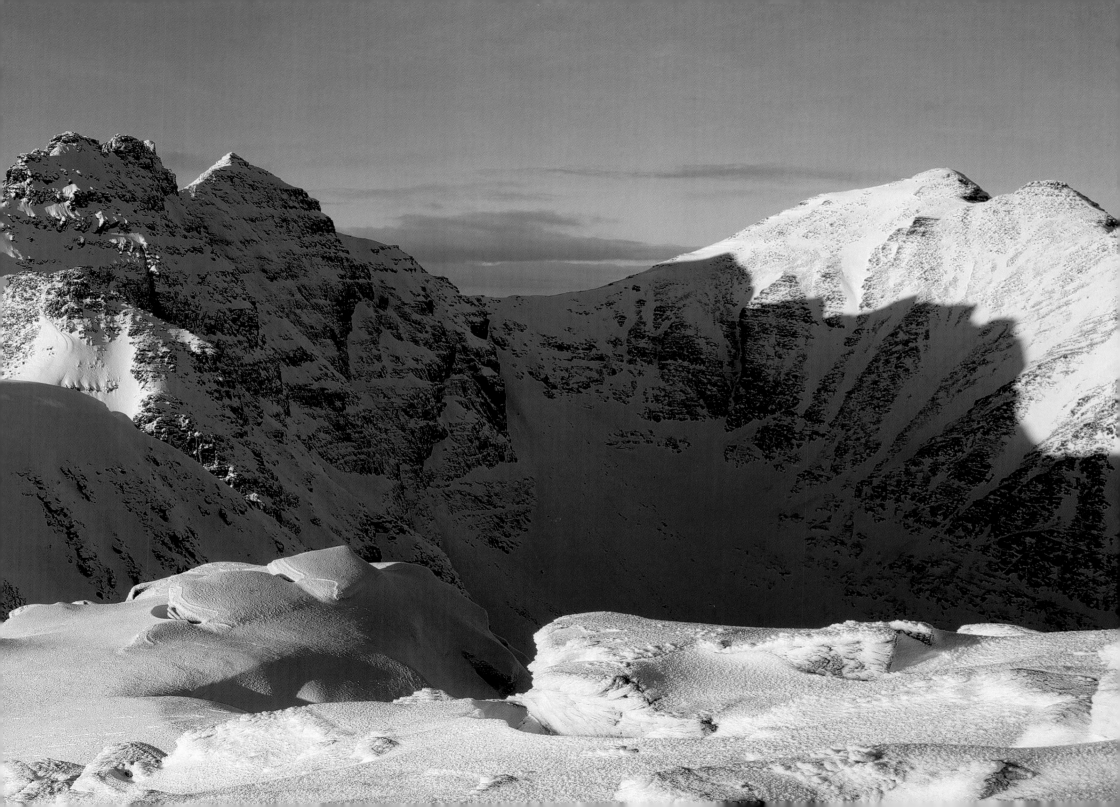

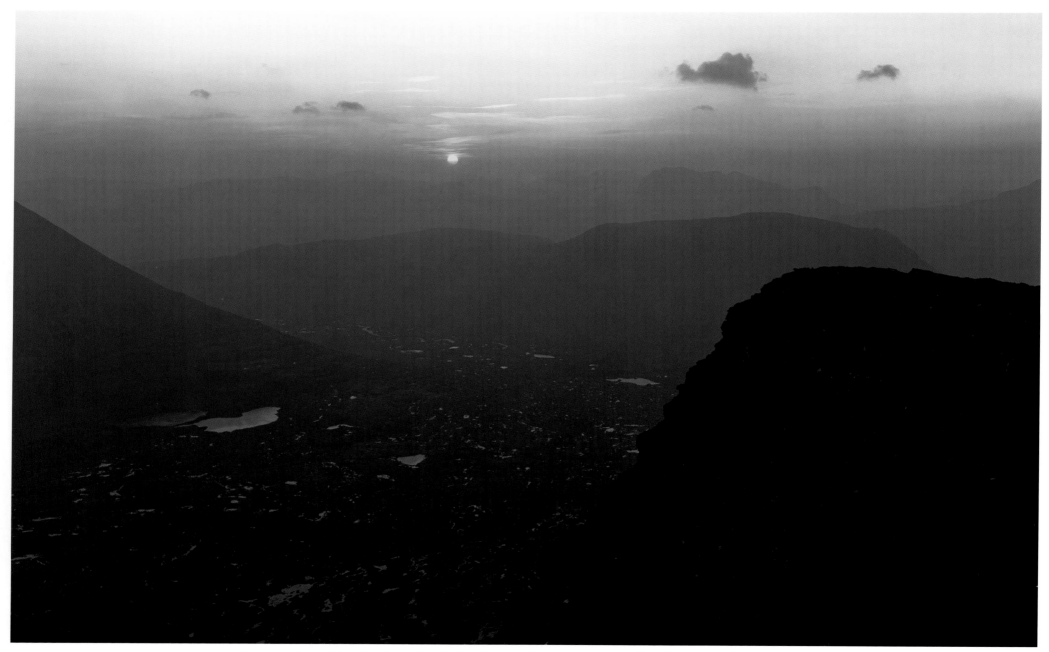

Sunrise from Stuc Loch na Cabhaig, the north-western top of Beinn Dearg in Torridon.

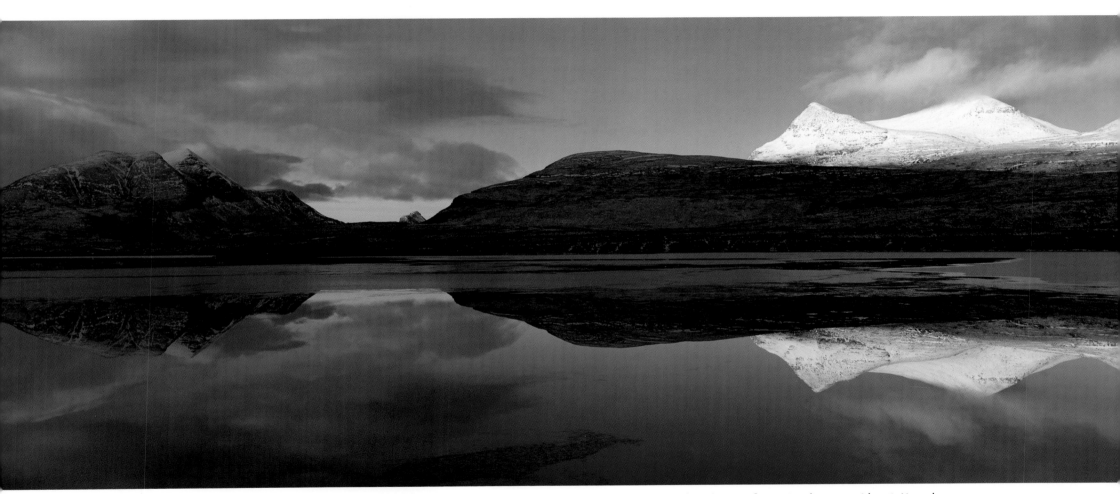

Entering the wonderful landscapes of the far north beyond Ullapool. Cul Beag and Cul Mor, from Lochan an Ais at Knockan.

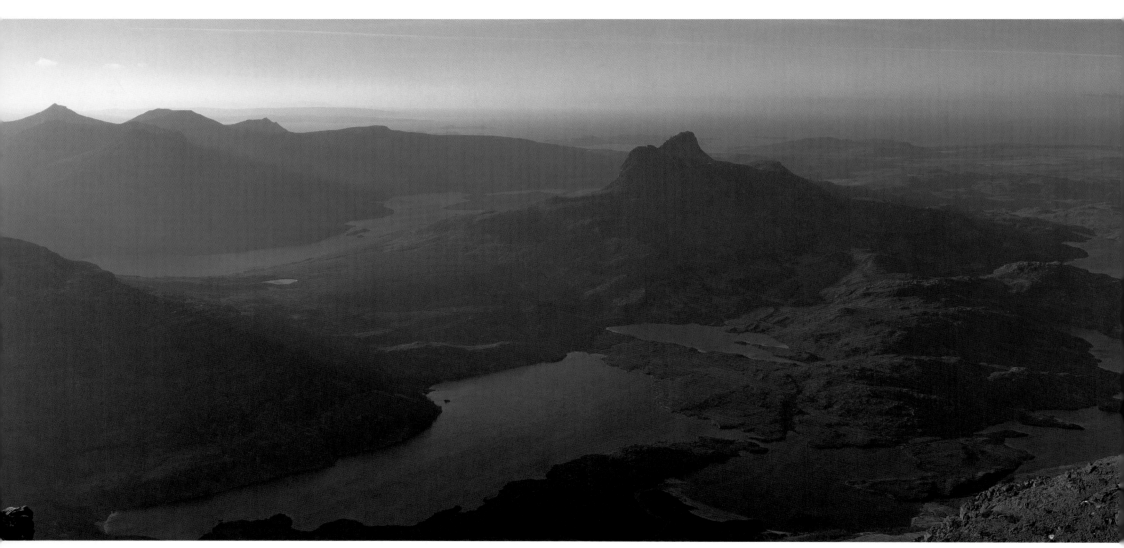

Stac Pollaidh, with Ben Mor Coigach to the left, from Cul Mor.

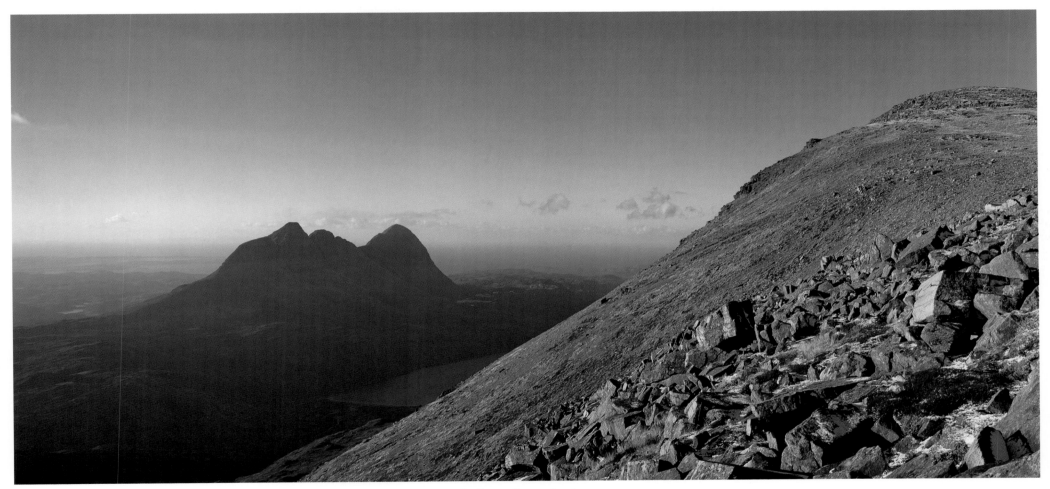

Suilven from Canisp.

On Caisteal Liath, the summit of Suilven, looking along the ridge to Meall Meadhonach with Canisp and Loch na Gainimh to the left *(pages 104-5)*.

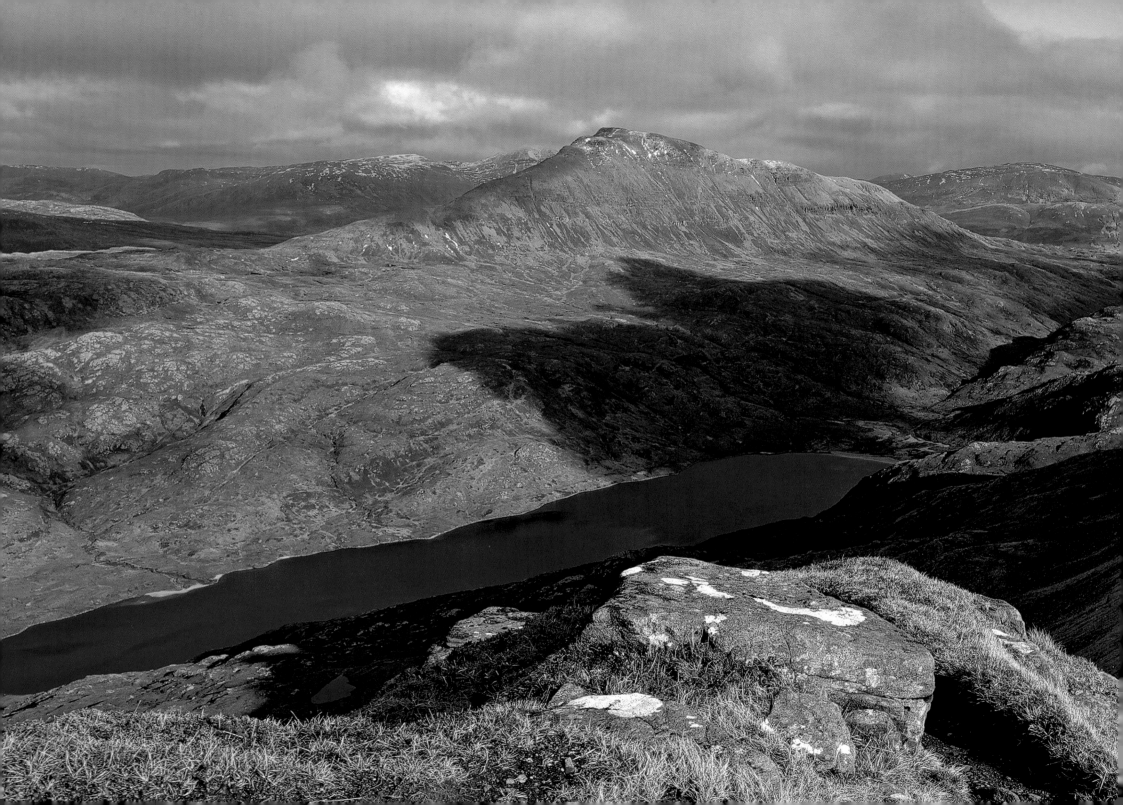

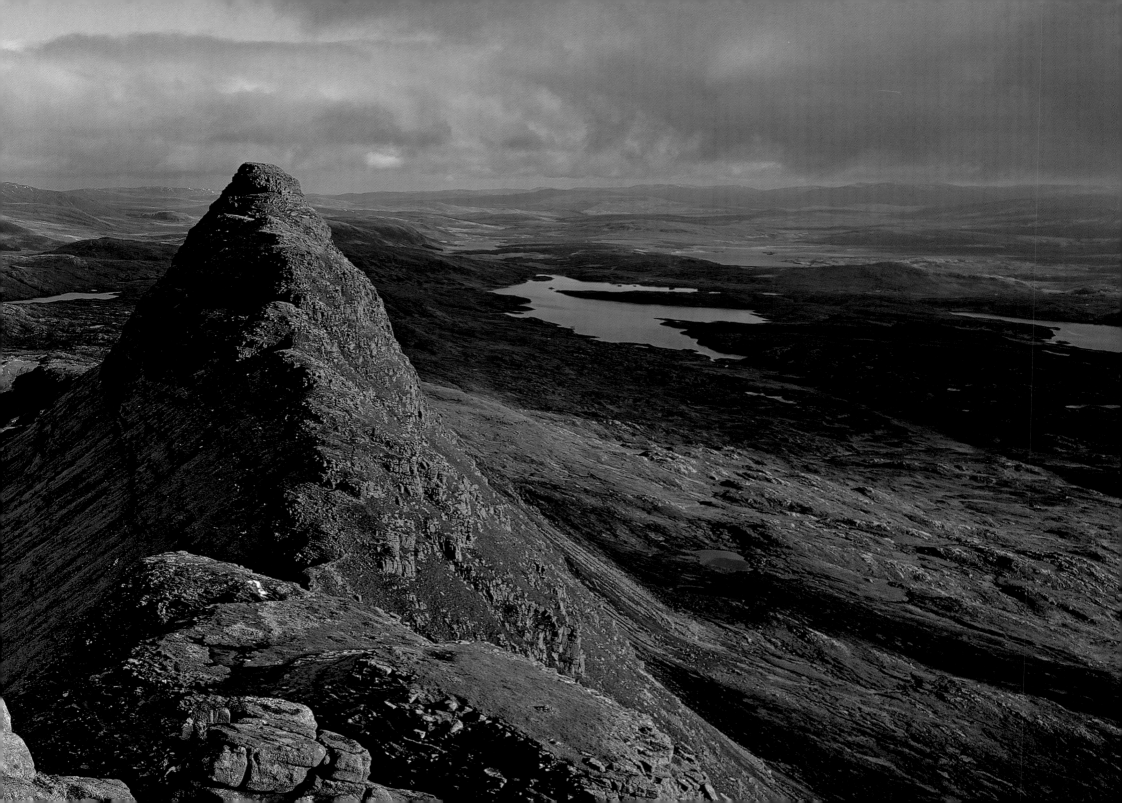

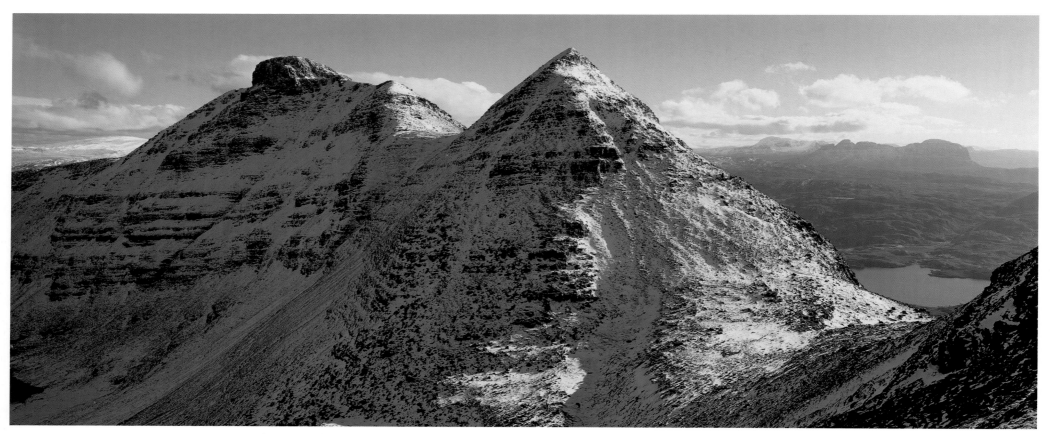

Quinag – Spidean Coinich from below the main summit, with Suilven in the distance.

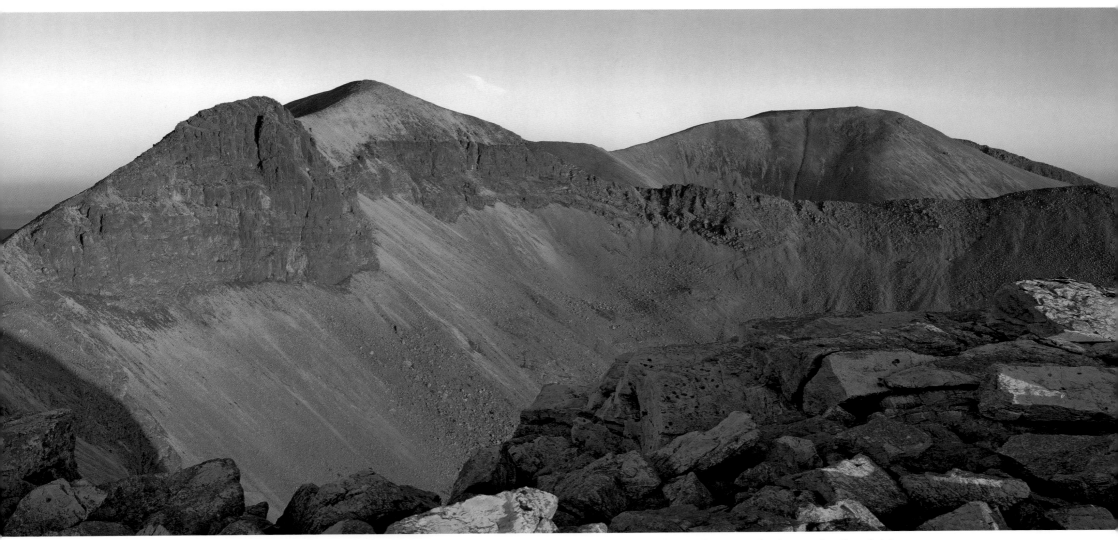

Sunrise on Foinaven, from below Stob Cadha na Beucaich. Ganu Mor, the main summit, is on the far right.

Looking south from the summit of Ganu Mor, Foinaven, through the Northern Highlands', catalogue – Arkle, Ben Stack, Meallan Liath Coire Mhic Dhughaill, Beinn Leoid, Ben More Assynt, Quinag, Canisp, Cul Mor, the Fannichs, An Teallach *(pages 108-9)*.

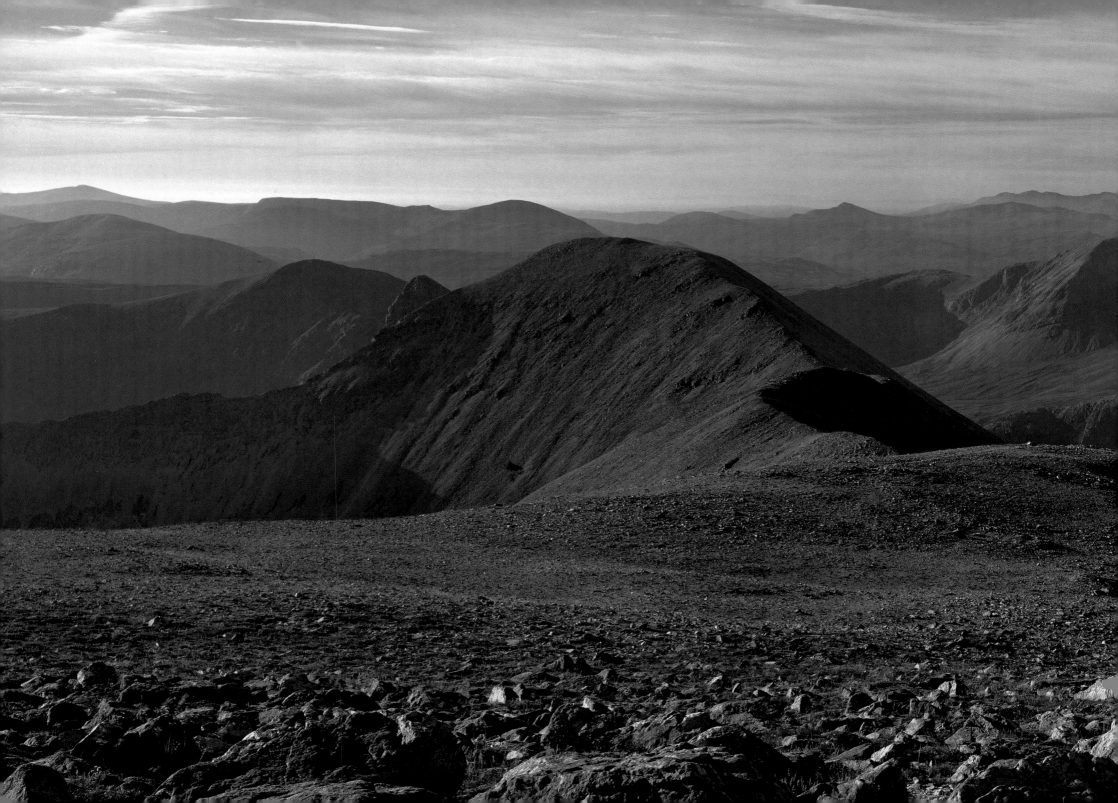

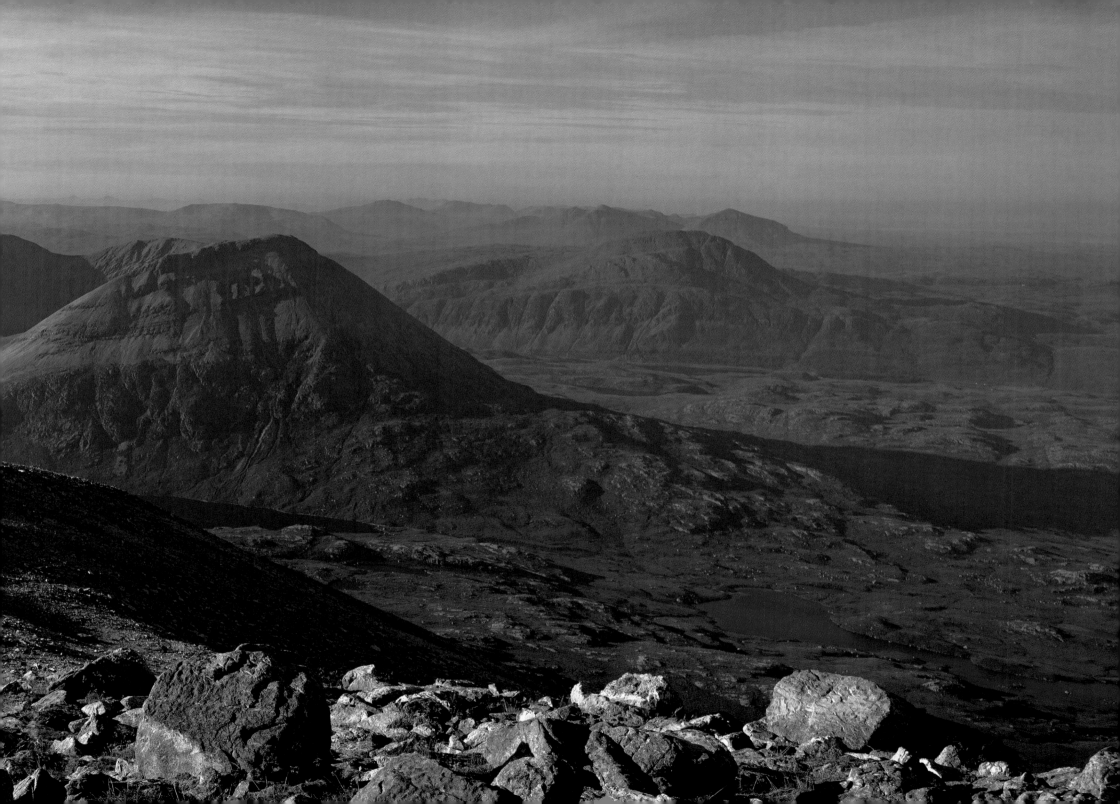

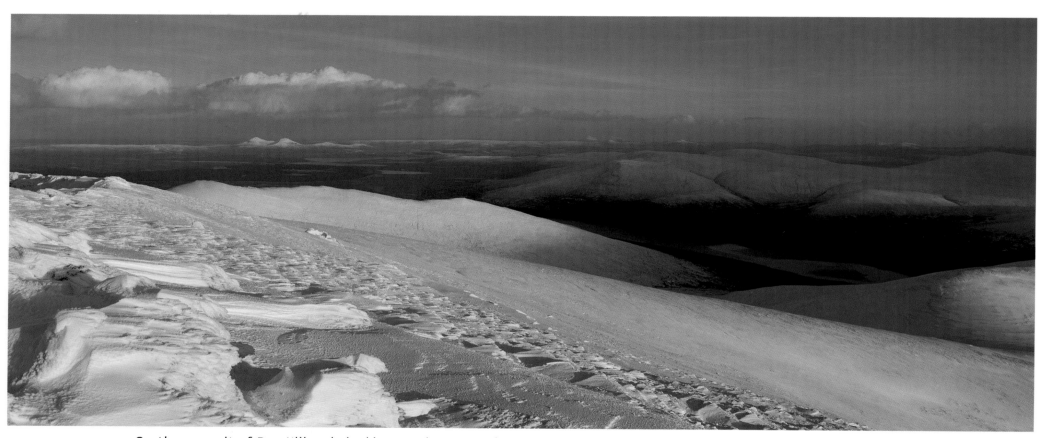

On the summit of Ben Klibreck, looking north east to the empty lands of the Caithness and Sutherland Flow Country.
Ben Griam Mor and Beg to the left, and the Ben Armine hills to the right.

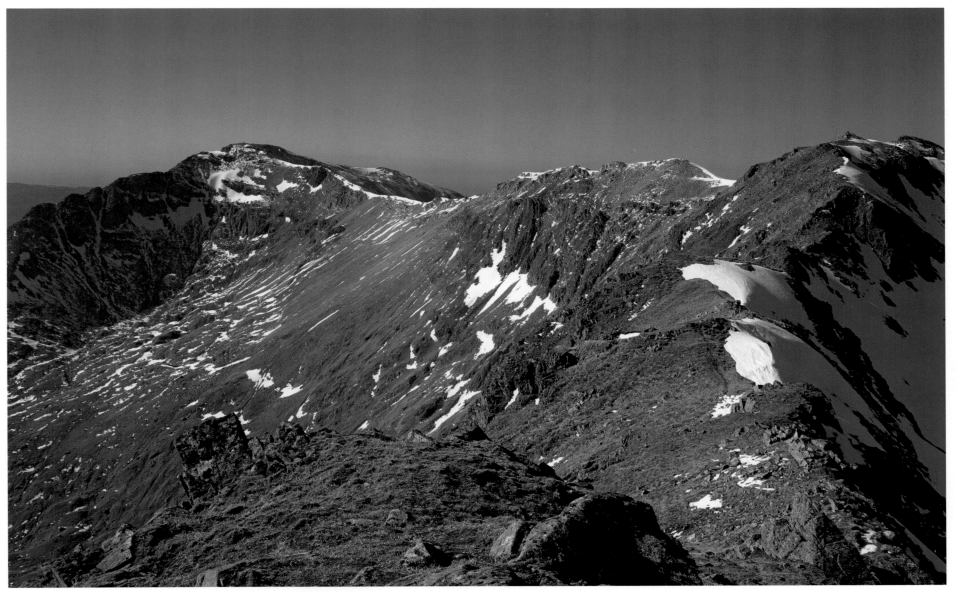

The Assynt Munros, Conival and Ben More Assynt, from the latter's south-east top.

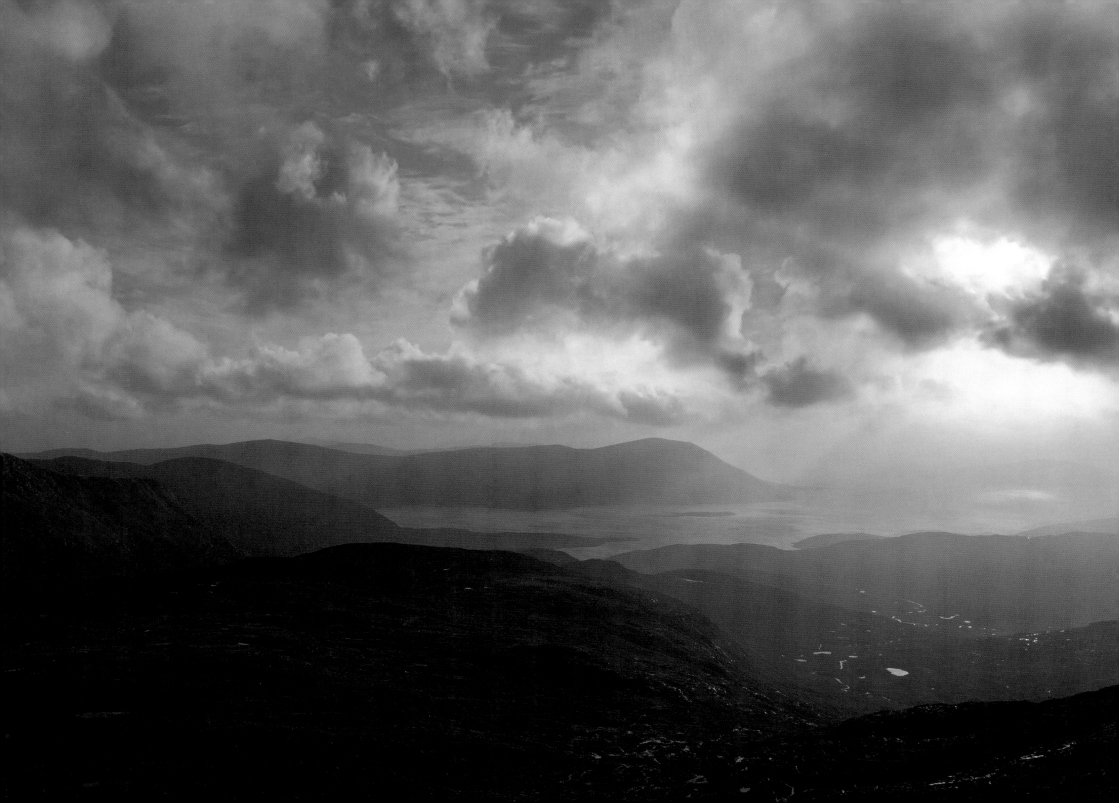

The Iconic Islands

There is nothing odd in having islands in a book of Scottish mountains. They are, after all, equally mountains but with water all round instead of just nearby, and some of our best hills are island hills. Above all else, island hills (the Scots are loathe to call anything 'mountain') give summit panoramas which cannot be bettered. Combined into one land mass the islands would prove as sizeable as any other area portrayed in this book, and scattered as they are, they emphasise the glorious variety of Scottish landscape. The Inaccessible Pinnacle in the Cuillin becomes a very small feature when compared to Stac Lee or Stac an Armin of St Kilda.

Some of the islands have blocks of hill or bigger ranges no less impressive than anywhere else; Skye's Cuillin is incomparable, the granite hills of Arran would not shame the Cairngorms, Mull is a showpiece, Rum's Cuillin and the Paps of Jura are as fine to look at, as from, and north Harris is wonderfully wild. Small can be powerfully beautiful too: the Shiants for instance, while Dun Caan on Rassay, the Sgurr of Eigg or Barra Head (Mingulay and Berneray) are unforgettable mountain features, set in sea as they are. Height is not important. Cuillin apart, Ben More in Mull is the only Munro and deservedly the most popular of all for completing the Munros on.

Braving the Atlantic the island hills receive more than their share of wildness and wet (Gerard Manley Hopkins take note). I once sheltered in the Sligachan pub one October day and overheard two locals talk. After a puff at his pipe the first suggested 'Aye, Donald, it's been raining since June.' The other considered awhile and then asked 'Just so. Which June?' I think he was joking.

The derivation of the name Arran may be 'high hill', which would not be inappropriate. Its Goatfell and the granite ridges above Glen Rosa and Glen Sannox make a crestline which fills every view across the Firth of Clyde. 'Mull of the Mountains' rears up to the tent-like crest of Ben More, the centre of volcanic activity long ago – as of course was the Cuillin of Skye, Scotland's most demanding and most satisfying of all ranges. The traverse of the Cuillin Ridge is still one of the those great mountain days, irrespective of scale or situation, and in the Scottish content, you cannot find better. Rum presents a mini-Cuillin. Incredibly, in 2007 a new record for running / climbing the Skye Cuillin ridge was set at 3 hours, 17 minutes.

The Outer Hebrides are mainly Lewisian gneiss, some of the oldest rocks in Europe, up to 3,000 million years old. More understandable, the last Ice Age ended about 10,000 years ago, leaving its telltale deep corries and lochs, erratics and scratch marks on the rocks. Loch Coruisk is deeper than the sea next to it and many areas in the Outer Hebrides are a patchwork of rock and water. The pounding Atlantic has created some of the world's most graceful sandy beaches.

At one time the islands were almost another country, the Lords of the Isles cocking a snoot at Edinburgh, an independence of outlook not entirely lost. Here are islands where Gaelic culture and language survive, where religion runs deep, where a hard but happier life lingers before the assaults of storms, natural or man-made, where the sea is still the main highway and the mountains are icons that inspire.

Sunlight and gales on Clisham in Harris, the highest summit in the Western Isles. Looking south to Loch a Siar, Beinn Losgaintir and Beinn Dhubh.

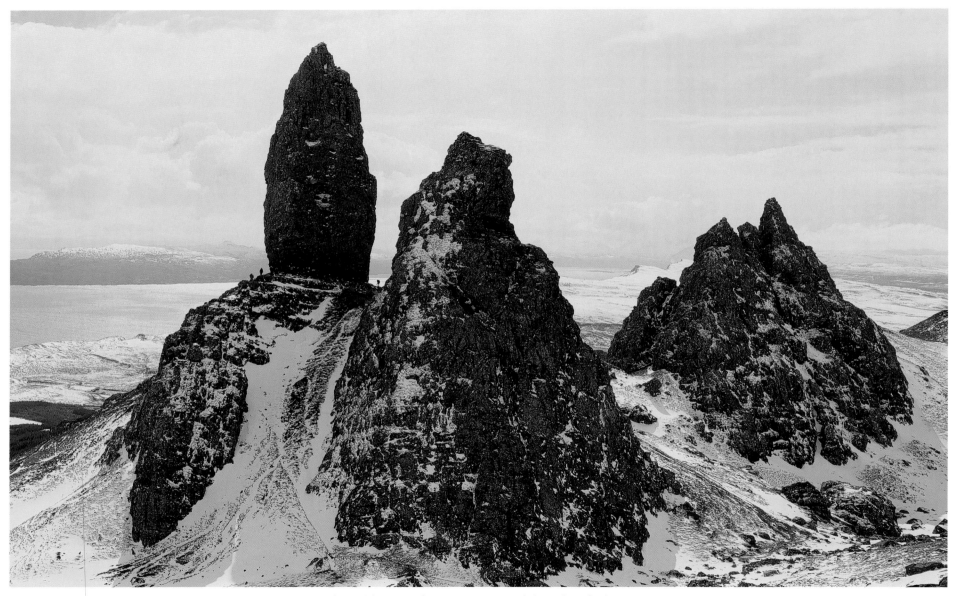

The Old Man of Storr, Trotternish, Isle of Skye.

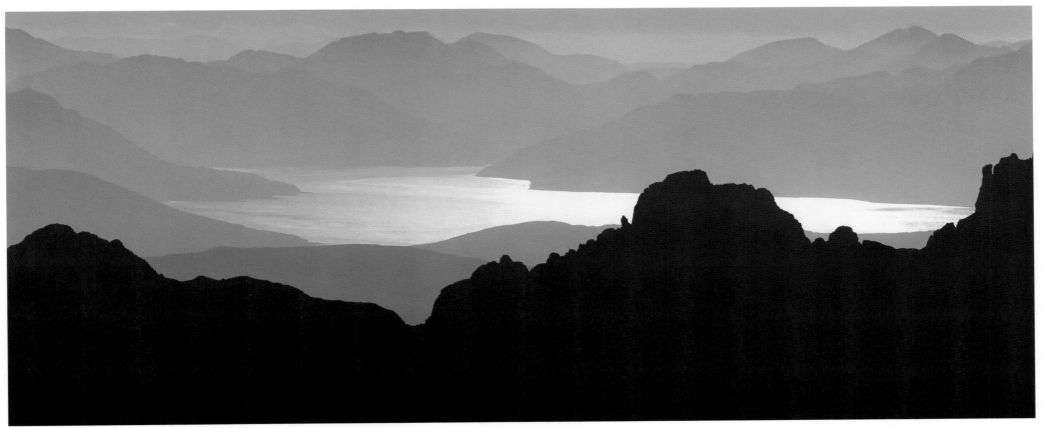

The ridge from Bla Bheinn, far right, over Clach Glas, centre, silhouetted against Loch Hourn, as seen from Sgurr nan Gillean.

The Cuillin ridge at sunrise, from the south ridge of Bla Bheinn *(pages 116-17)*.

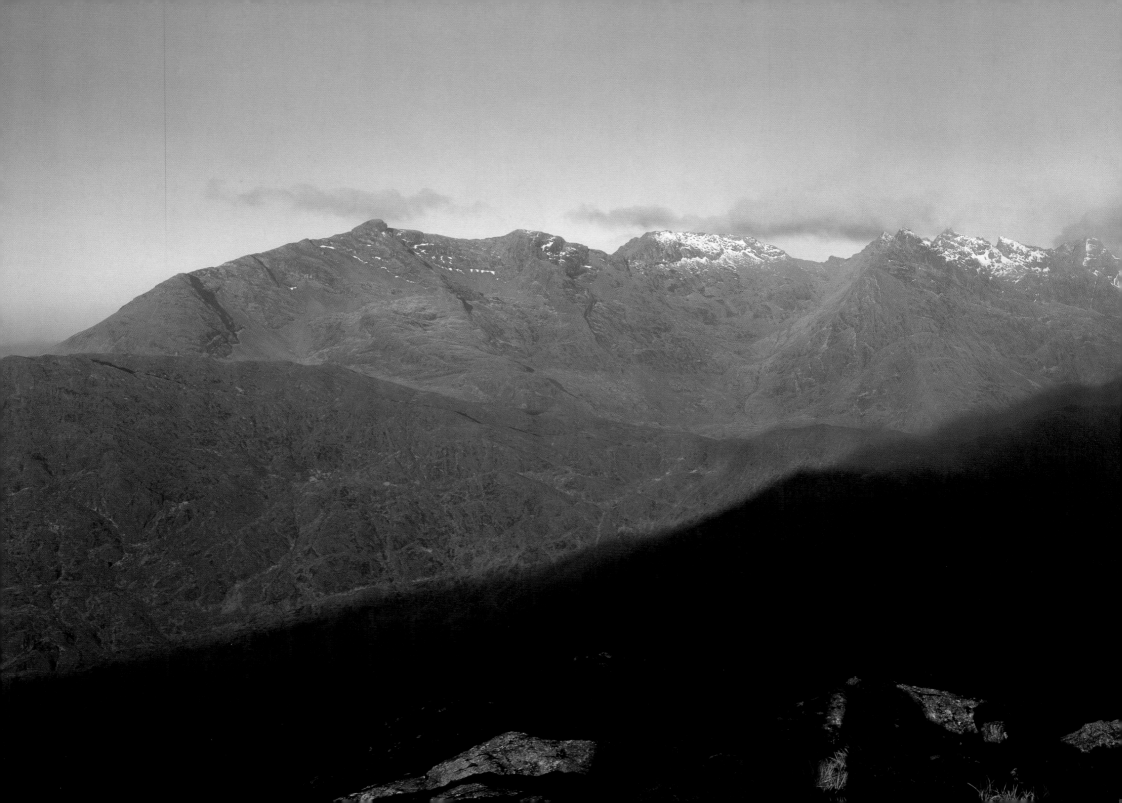

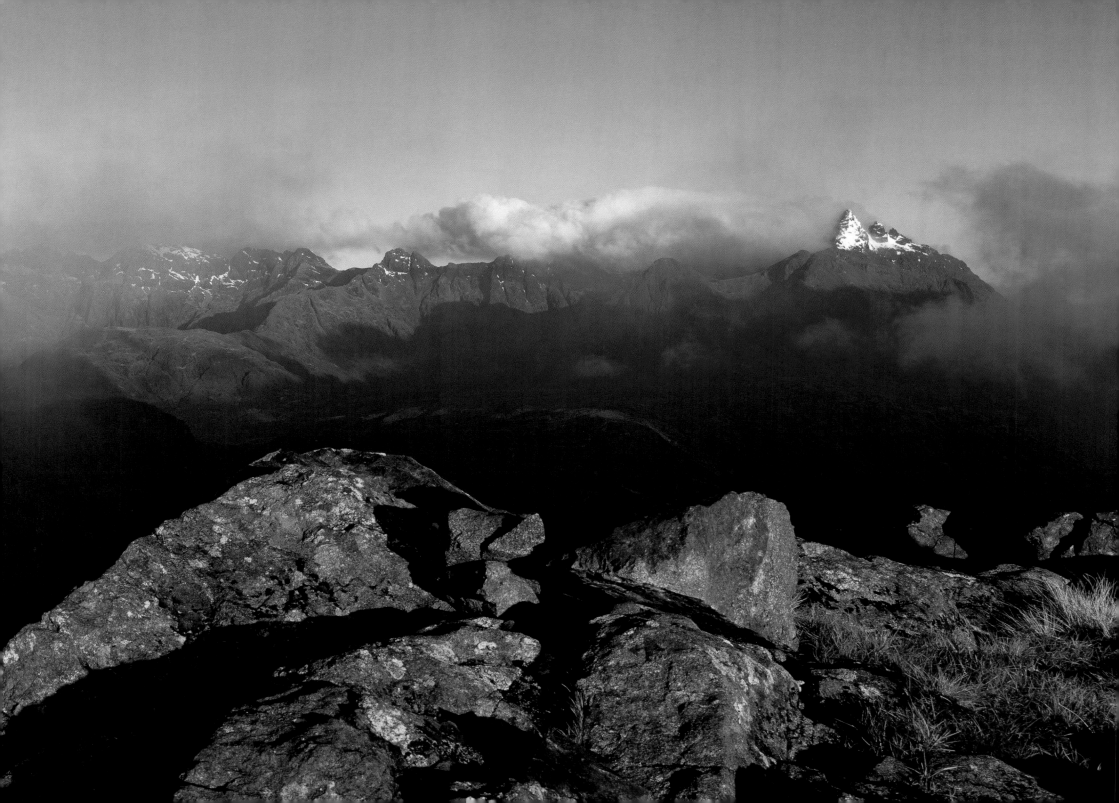

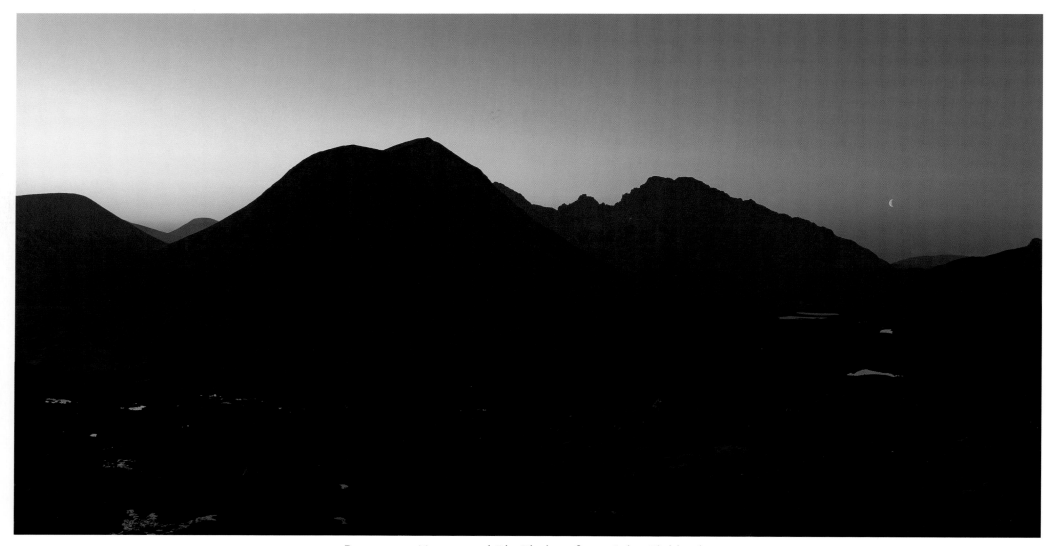

Dawn over Marsco and Bla Bheinn, from Coire Riabhach.

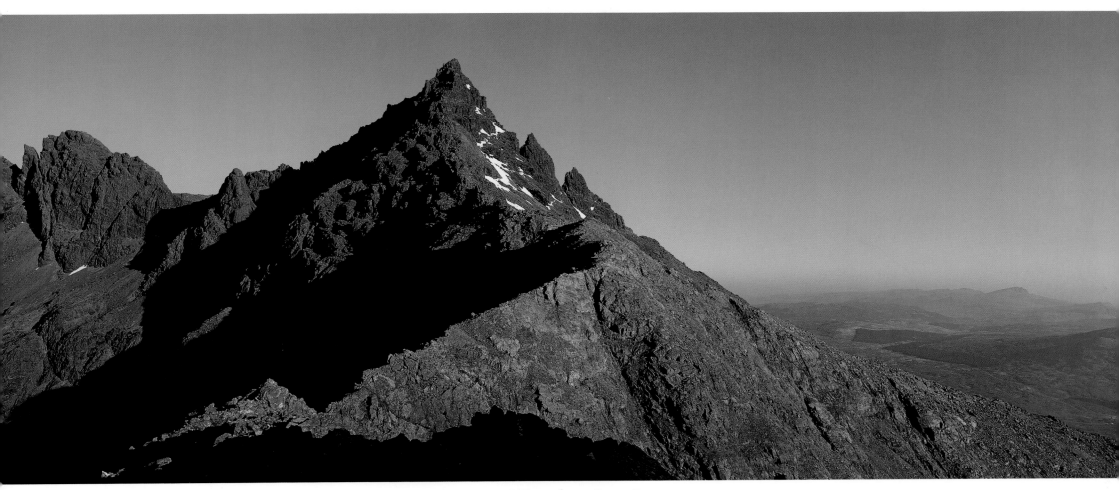

Sgurr nan Gillean from Sgurr Beag.

A glorious, but snowless, day on the Cuillin in December ends on Sgurr Alasdair with a memorable sunset *(pages 120-1)*.

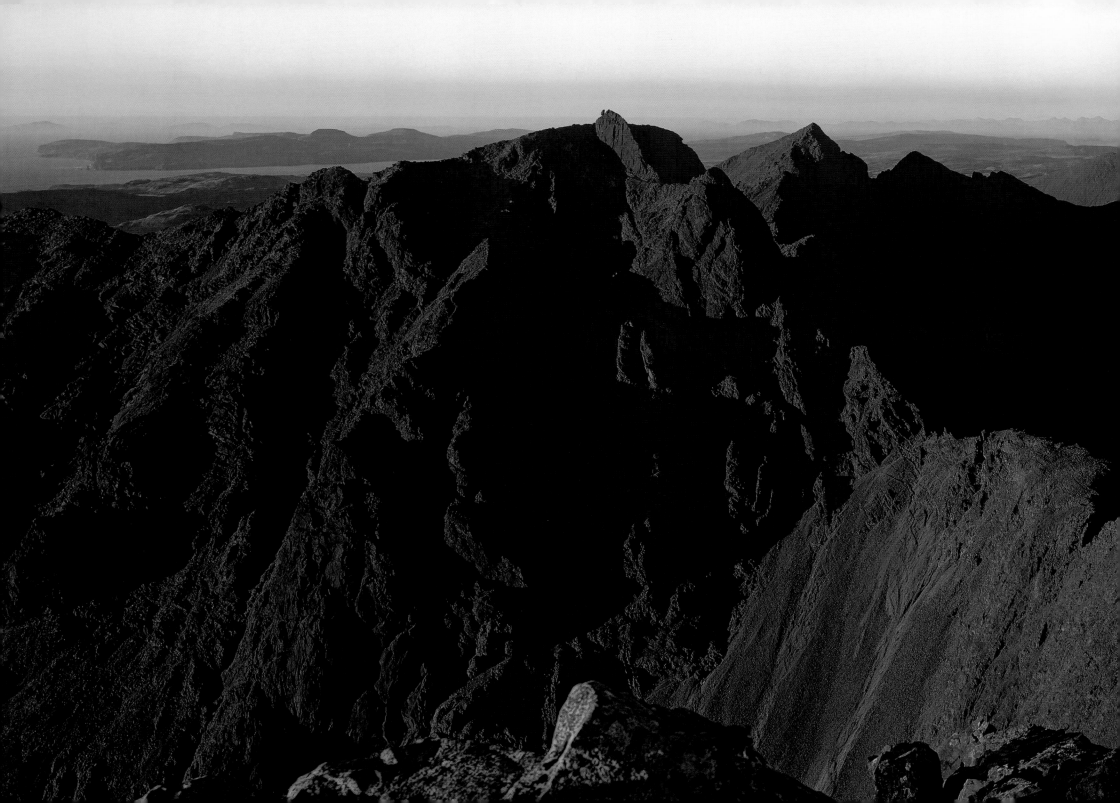

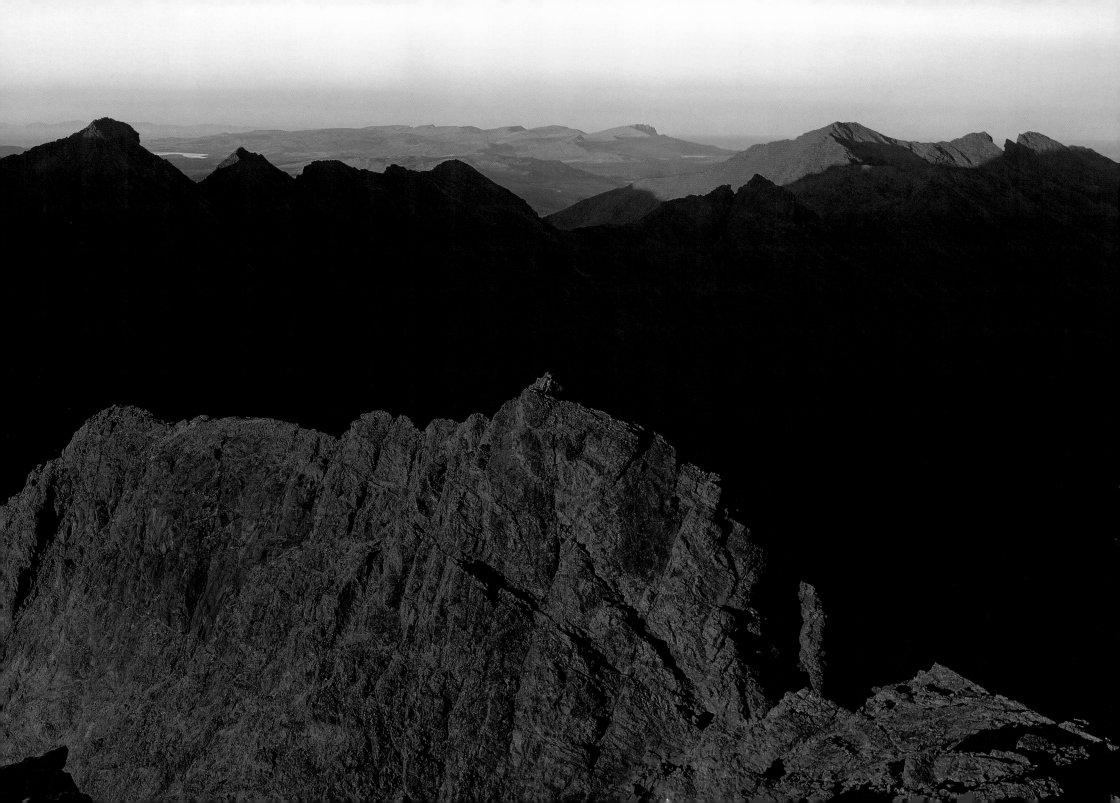

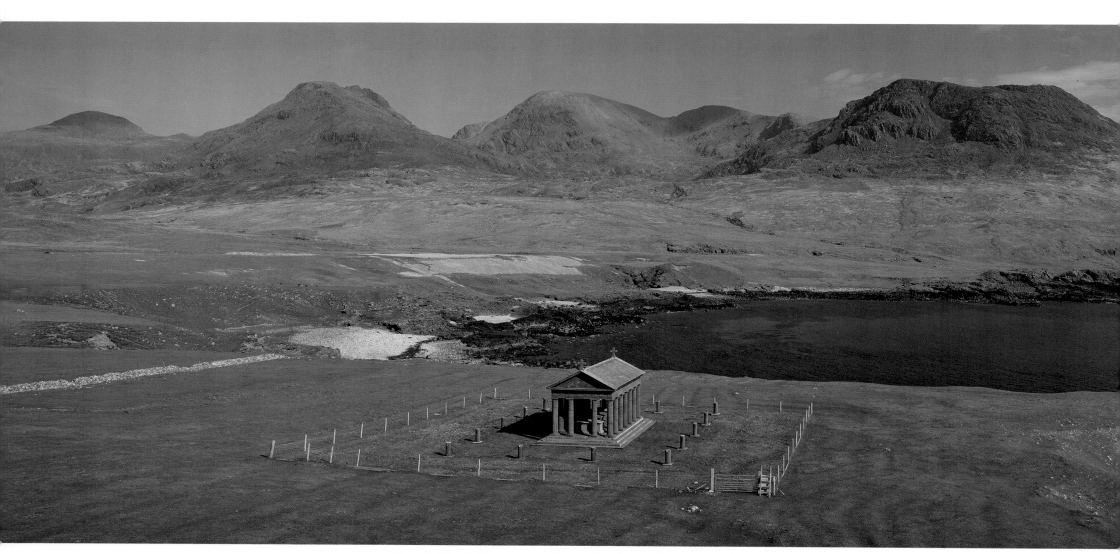

The Cuillin hills on Rum from the foot of Glen Harris.

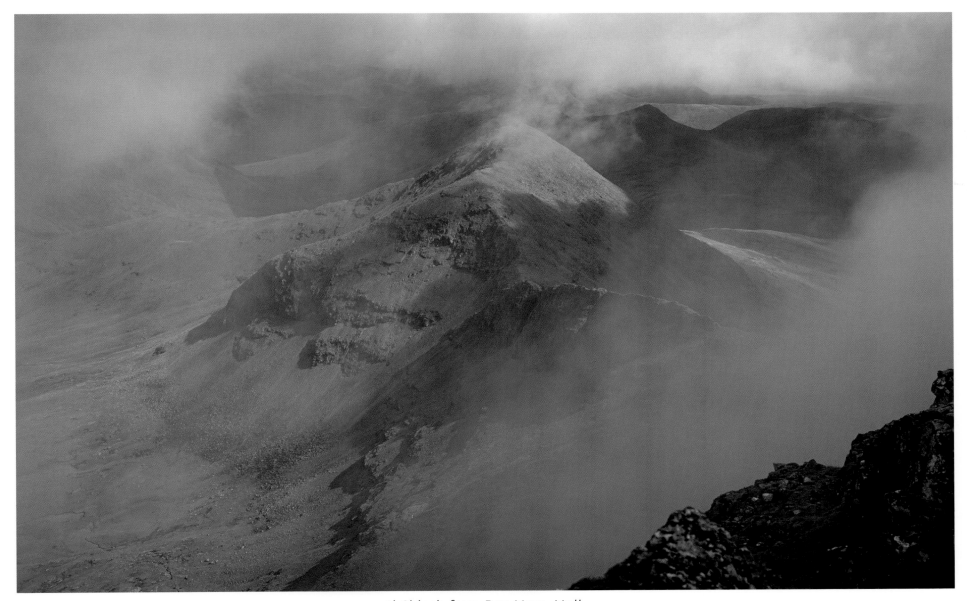

A' Chioch from Ben More, Mull.

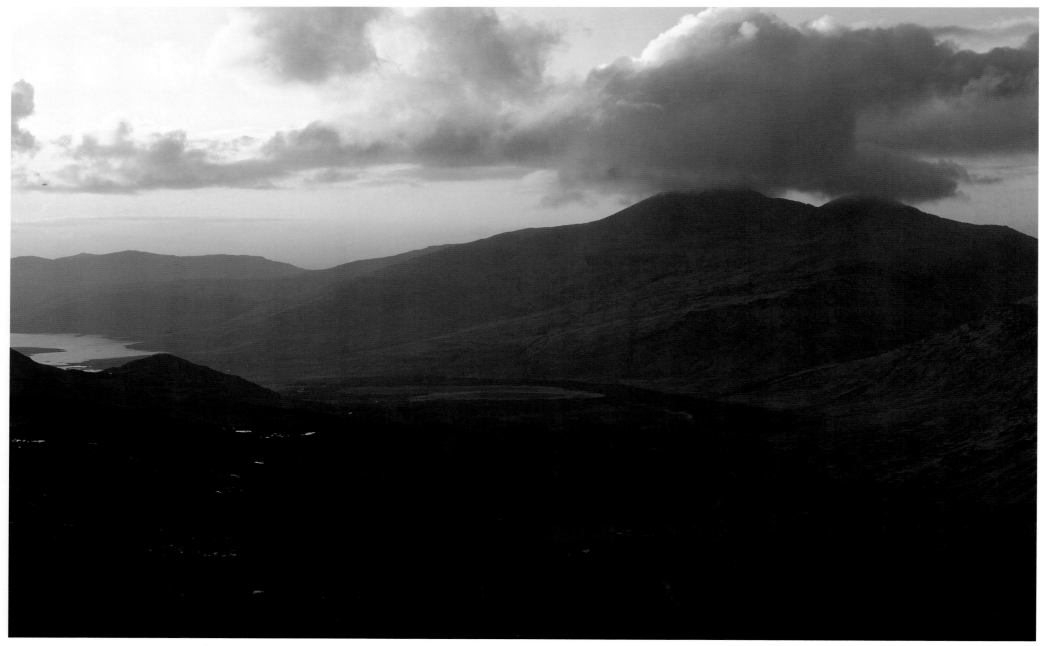

Ben More and A' Chioch from Ben Buie, Mull.

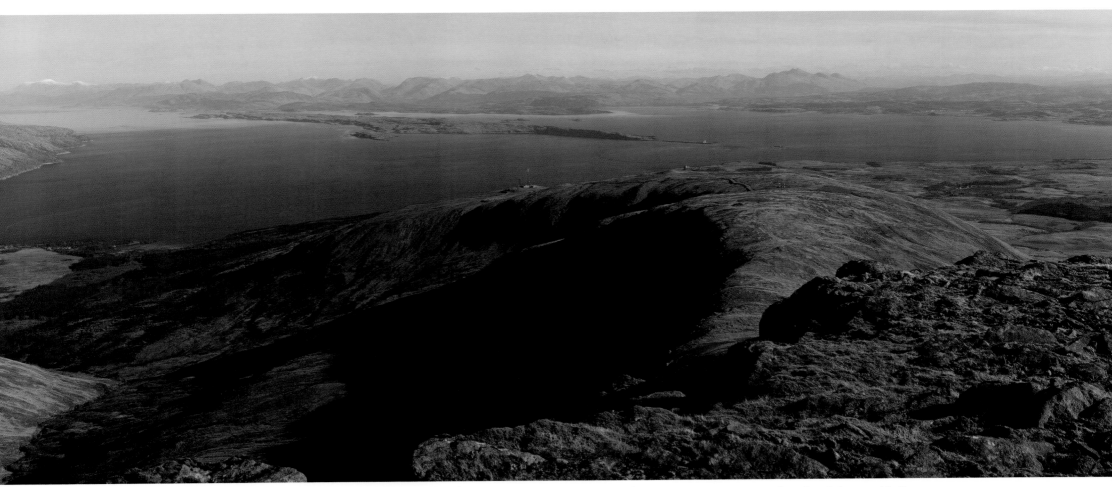

The mainland hills, from Ben Nevis in the north to Beinn Bhuidhe in the south, from Dun da Ghaoithe on Mull.

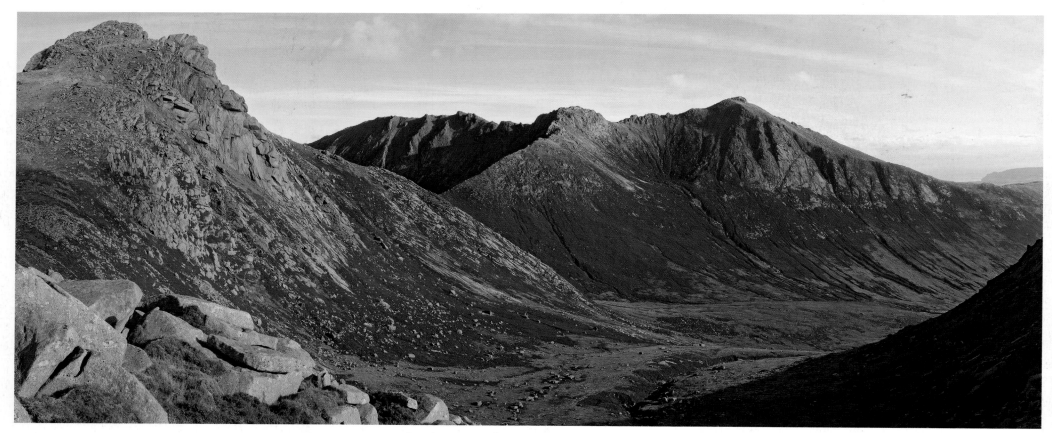

Cir Mhor, Goatfell and Glen Rosa, Arran.

Sunrise on the Arran hills. Cir Mhor, A' Chir and Beinn Tarsuinn from Caisteal Abhail *(opposite)*.

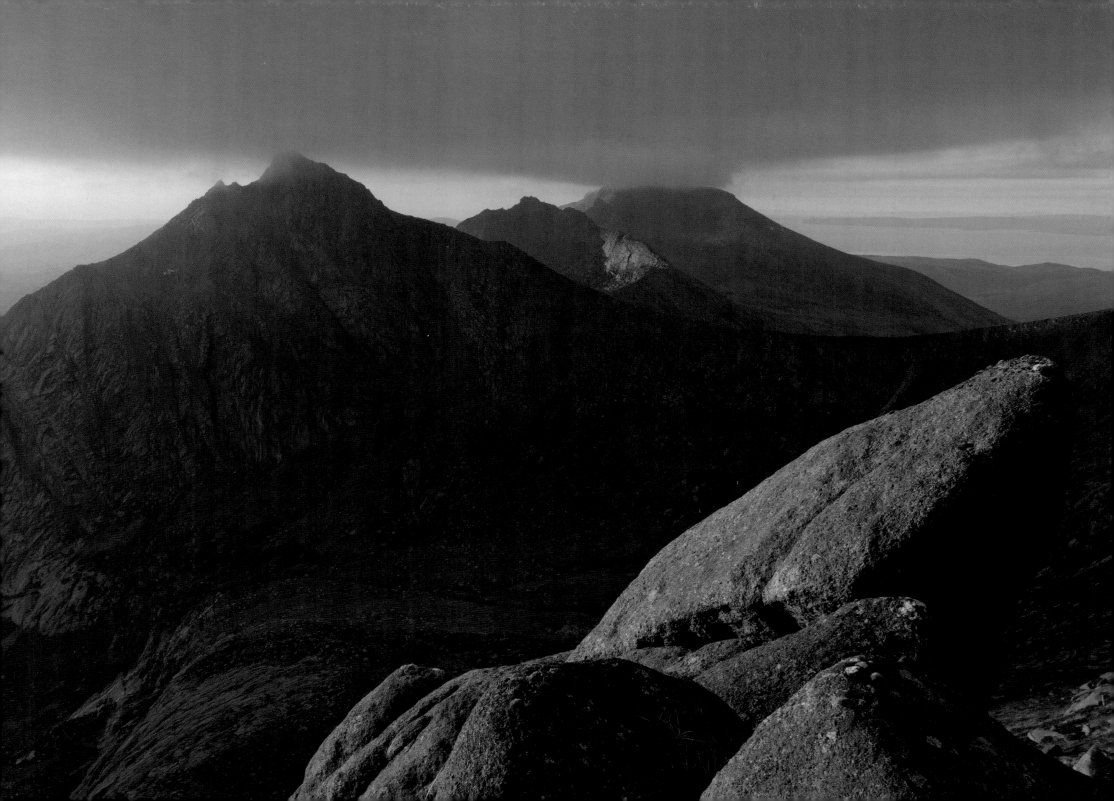

Index of Places